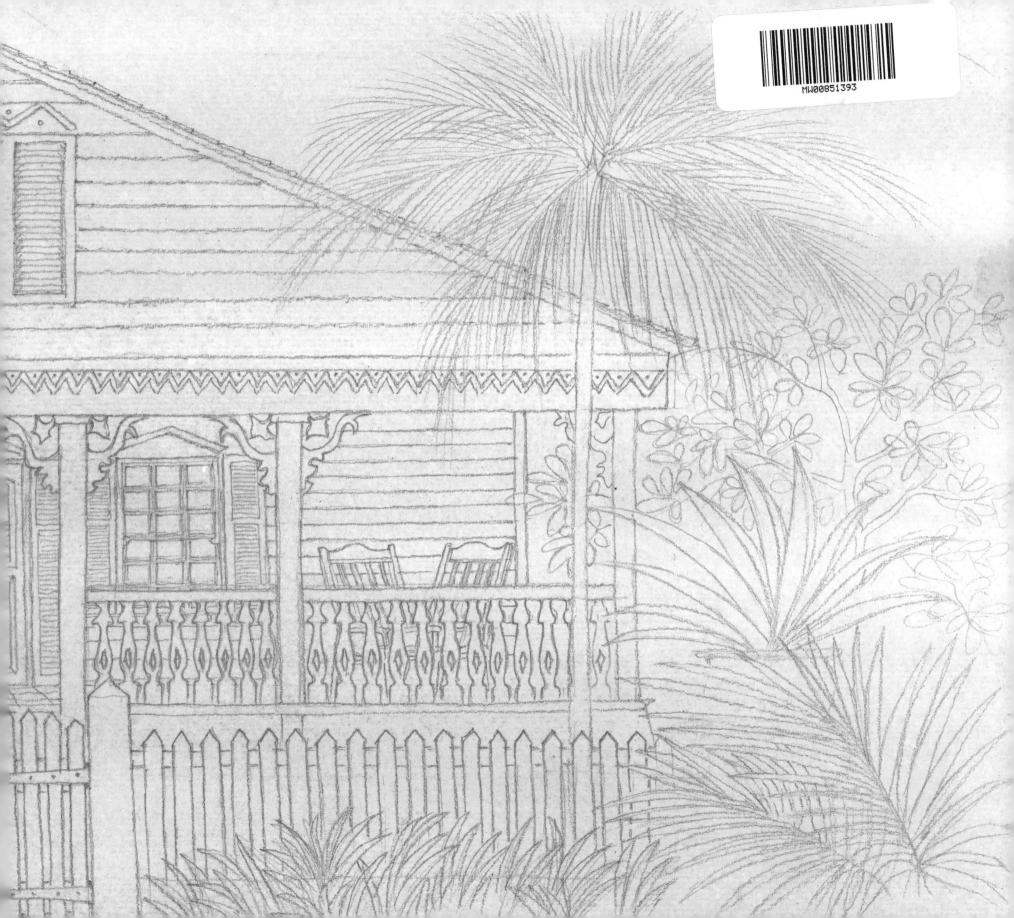

Sometimes we get so caught up in what is new and current, we miss the beauty and elegance of the past.

You may have passed these buildings hundreds of times; you probably don't even see them anymore. I encourage you to stop, look carefully at the details captured so beautifully, allow yourself the time to search out other buildings, stand in front of them and see the dreams of those who designed them, the care with which they were built and the stories of those who lived within their walls.

Appreciating beauty and appreciating history will touch a place inside of you that gets so lost in our busy days.

Graham has challenged us to see the beauty right in front of us and for that I am grateful.

Joann McPike

Editorial Director: Douglas Amrine
Editor: Rachael Morris
Designer: Lisa Damayanti
and Graham Byfield
Production Manager: Sin Kam Cheong

First published in 2013 by
Editions Didier Millet
121 Telok Ayer Street, #03-01
Singapore 068590
www.edmbooks.com

Colour separation by United Graphic Pte Ltd, Singapore
Printed by Tien Wah Press, Singapore

ISBN 978-981-4385-58-9

Printed on 160gsm Modigliani Neve

Artist's Acknowledgments

Out of painful experiences good things can come. When my partner died suddenly, I travelled round the world to see friends who knew her well. I finished up at the house of my cousin, Bonny Byfield, who lives in the Bahamas. Walking around Nassau and admiring its historic architecture, I felt encouraged to paint. It is thanks to Bonny that this book got started. With her enthusiasm and my interest in architectural heritage, the project slowly developed. I am very grateful to the like-minded sponsors, who are interested in the preservation and conservation of Nassau's architecture. My thanks must also go to Rosanne Pyfrom for her hospitality on Eleuthera and to Ronn Macdonald for creating a studio for me. It has been a great experience recording the interesting parts of the Bahamas islands in watercolour. Thanks are due to Larry Smith for his knowledgeable and incisive writing. I am also very grateful to my friend Jayne Norris for her hospitality and generous support during my long visit to Singapore to finish this sketchbook. And at EDM my publisher, thanks must go to my editor Rachael Morris and my designer Lisa Damayanti. They are a great team. I hope this book will increase awareness of and interest in the history of Nassau and the Family Islands' architecture, as well as arouse greater efforts in preserving it.

Graham Byfield

The production of *Bahamas Sketchbook* has been made possible with the generous support of these sponsors:

GOLD

 Joann McPike

SILVER

 Tanya and John Crone

Bahamas Sketchbook

Islands in the Sun

Watercolours by Graham Byfield

Text by Larry Smith

edm EDITIONS DIDIER MILLET

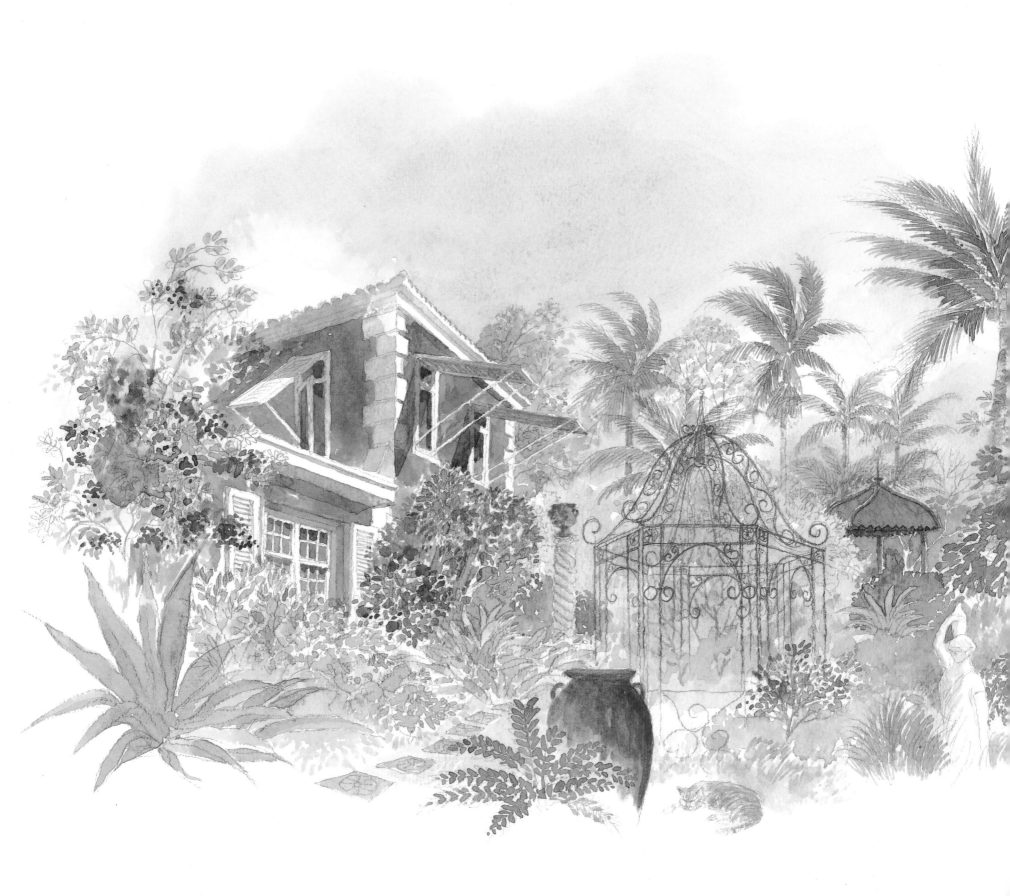

Contents

Introduction

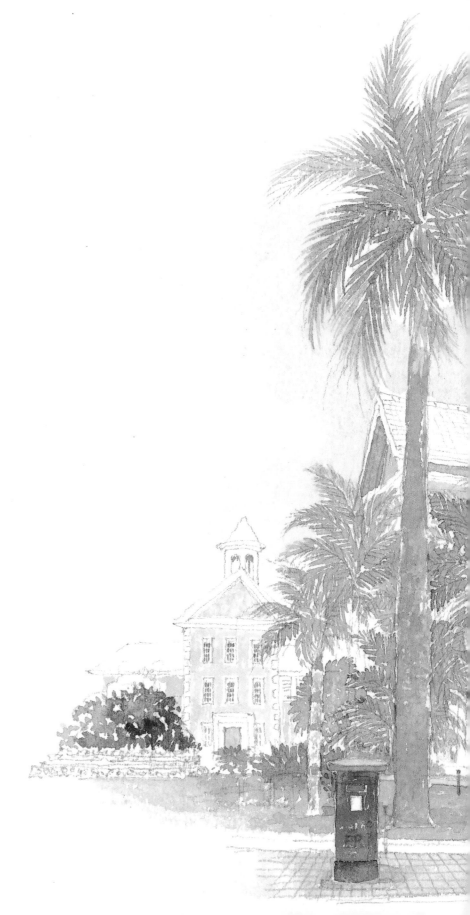

"The island...was discovered by Capt. William Sayle, who was afterwards governor of Carolina. He was driven thither by a storm, as he was on a voyage to the continent [of America]. From him it had the name of Sayle's Island...People went from England and the other colonies to settle there, and living a lewd, licentious sort of life, they were impatient of government." – John Oldmixon, 1741

The name "Bahamas" first appears in the historical record a few years after Columbus's accidental landfall in these islands just off the Florida coast. Thought to be a corruption of the Lucayan term for the island of Grand Bahama, the earliest English reference occurs in the account of a 1567 voyage, in which the "chanell and gulfe of Bahama, which is between the cape of Florida and the Ilandes of Lucayos" is mentioned.

The pre-Columbian Bahamians were known as Lucayans (a corruption of Lukku-Cairi, meaning island people). Over centuries they migrated north from Venezuela to the greater Antilles, where they created the Taino culture, arriving at the end of their journey in the Bahamas about 600 AD. It is thought that some forty thousand Lucayans may have lived in the Bahamas at the time of their encounter with Columbus in 1492.

In search of riches, the Spaniards who followed Columbus had little interest in the poor Bahamian islands but forced the hapless Lucayans into slavery in Hispaniola, where they died helping to establish the first European colony in the Americas. After 1500 the Bahamas was virtually deserted, until English puritans from Bermuda arrived on the island of

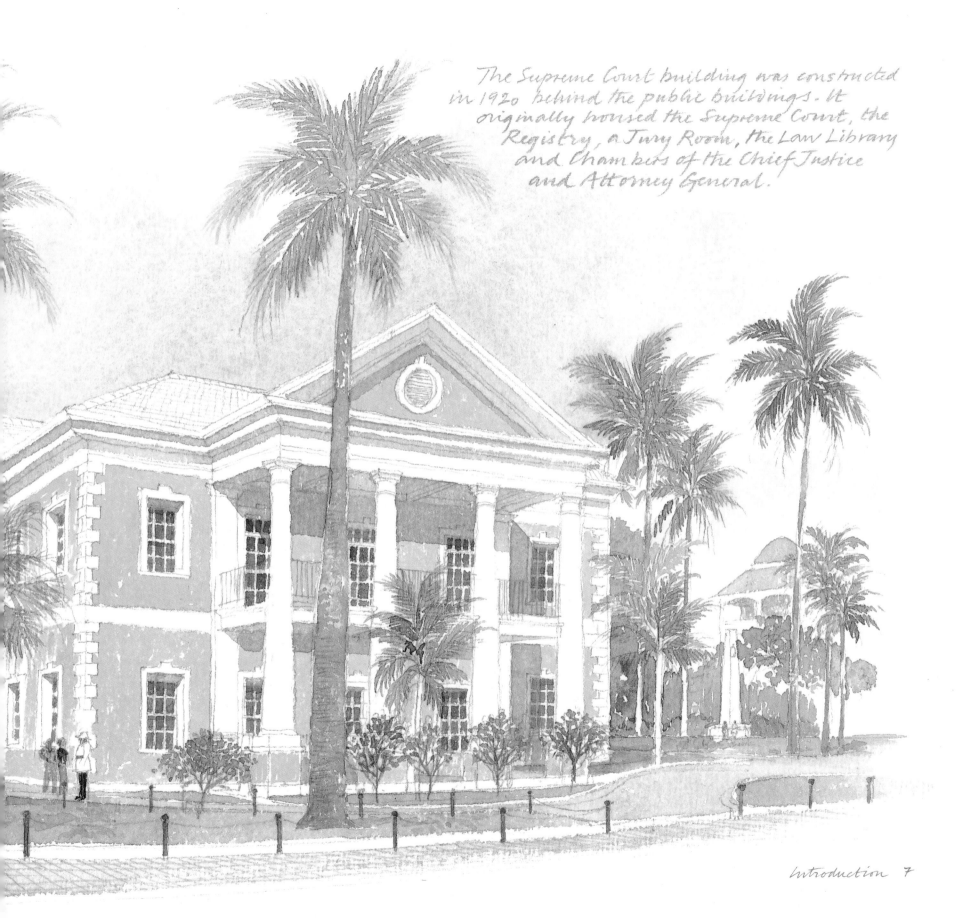

The Supreme Court building was constructed in 1920 behind the public buildings. It originally housed the Supreme Court, the Registry, a Jury Room, the Law Library and Chambers of the Chief Justice and Attorney General.

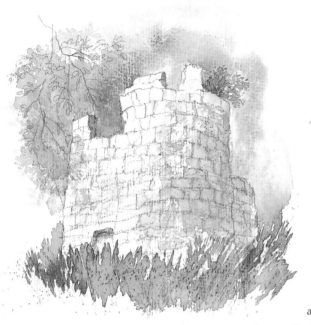

Eleuthera in the mid-1600s, led by a former Bermuda governor named William Sayle.

Some of these early colonists also settled on nearby New Providence, originally known as Sayle's Island, and by 1670 Charles Town (as the settlement was then called) had a few hundred inhabitants. In 1695 the little town was formally laid out by Governor Nicholas Trott and rechristened Nassau in honour of the Dutch ruler, Prince William of Orange-Nassau, who had become king of England. Back then, there were some 160 buildings hugging the harbour formed by Hog Island – now called Paradise.

Little remains of that 17th-century settlement other than the central street layout between the ridge and the harbour. Nassau remained relatively undeveloped before the Bahamas became a British Crown colony in 1718 because the islands had become a lawless pirate republic led by larger-than-life characters like Ben Hornigold, Charles Vane and Blackbeard. These buccaneers were part of "a maritime revolt that shook the very foundations of the British Empire" between the late 17th and early 18th centuries, according to author Colin Woodard.

When Woodes Rogers, the first royal governor and himself a former privateer, arrived on the scene, the town of Nassau was inhabited by several hundred pirates together with scores of other residents who "live poorly [and] indolently...and pray for nothing but [ship] wrecks or the

pirates". As Rogers complained to his superiors in London, the inhabitants "would rather spend all they have in a punch house than pay me [a tax] to save their families."

But despite this less than auspicious beginning, Rogers was able to enlist those pirates willing to reform – while executing those who wouldn't – and set about securing and refurbishing the town and its fortifications. In 1729 he was responsible for calling the first general assembly. Within a few decades Nassau was stable enough for the assembly to pass an act "for re-surveying the town", creating new roads to connect the expanding eastern and western districts, and setting the stage for the arrival of thousands of continental refugees fleeing the American Revolution.

The loyalists who migrated from New York, Florida and the Carolinas with their African slaves built plantations on New Providence (and other islands now known as the "out islands"), such as Clifton, Hobby Horse Hall and Tusculum (many of whose names survived into the 20th century). They also built some of the city's finest structures, still in use today, including St Matthew's Church, the House of Assembly, the old law courts facing Rawson Square and a new home for the governor on Mt Fitzwilliam.

According to historian Gail Saunders, "The architectural styles of the southern states and New England towns were transported to Nassau." And by the late 1700s the town stretched from West Street to East Street, bounded on the north by Bay Street and on the south by East Hill and West Hill streets, flanking Government House.

This old tiled plaque is mounted on the gateway where the hotel once stood.

The loyalist attempt to transplant American plantation society to a chain of small arid islands failed due to soil exhaustion, pest insects and hurricanes, as well as the British abolition of the slave trade in 1807 and of slavery itself in 1834. After 1807 the Royal Navy settled thousands of Africans, liberated from slave ships, on New Providence, where they established, on the outskirts of Nassau, peasant communities that now form the area known as Over-the-Hill.

By the 1840s Nassau had a population of some eight thousand, and the pace of life began to quicken. For decades a benign climate had attracted wealthy travellers for health reasons, as this 18th-century report by a British official testifies: "The Bahama Islands enjoy the most serene and the most temperate air in all America, the heat of the sun being greatly allayed by refreshing breezes from the east, and the earth and the air cooled by constant dews which fall in the night and by gentle showers which fall in their proper seasons."

In the 1860s tourism became an official industry for the first time, with the inauguration of a Nassau–New York steamship route and the construction of the ninety-room Royal Victoria Hotel (demolished in the 1970s), which was then the largest building in the town. The outbreak of the American Civil War in 1861 also brought droves of Confederate blockade runners and Union spies into the colony.

Nassau became one of the busiest ports in the region during this period, when the north side of Bay Street was reclaimed for warehouses and wharves while the street itself was provided with kerbstones and lights. At the time, a local newspaper compared the harbour to its pre-war state: "There were no quays along the strand, and instead of vessels lying, as they now do, along the shore loaded and unloaded by a steam crane, they were approached only from the middle of the harbour by lighters."

But despite these developments, the city as we know it today was largely built from revenue generated by the smuggling of liquor to the United States during the Prohibition years, from 1920–33. This was a time when easy money fuelled a speculative land boom, the first tentative air links brought in many more visitors, and modern infrastructure like the cruise port, water and sewerage system, electricity grid and new residential suburbs were grafted onto the old Georgian capital built by the loyalists.

Fort Montagu dates from 1741, when it was constructed to guard the Eastern shore of Nassau.

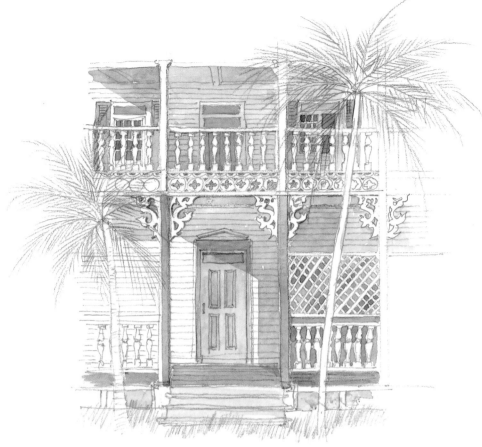

A typical piece of vernacular architecture, which is a feature along East Bay Street.

The modern contours of the Bahamas began to take shape in 1923, when the harbour was dredged and the soil used to create Clifford Park below Fort Charlotte. A nine-hole golf course was laid out here, and another was built at Cable Beach. The new Hotel Colonial on Bay Street became the centre of Nassau's social life. And nearby Paradise Island beach was a major "sea bathing" attraction for tourists, many of whom arrived on the first scheduled Pan Am air services from Miami.

During Prohibition, the Bahamas was once again considered a "land of rascals, rogues and peddlers", and according to the *London Daily News*, Bay Street was little more than a row of "crazy old liquor stores, unpainted and dilapidated, [that] have given it the nickname of booze avenue."

According to an official US Coast Guard history, "Enormous profits were to be made, with stories of 700 per cent or more for Scotch or Cognac. Probably the only reliable clue to the extent of the trade were the statistics on liquor passing through Nassau en route to the US: 50,000 quarts in 1917 to 10,000,000 in 1922."

One American visitor described a typical tour of New Providence at the time: "We started from Bay Street, with its row of little shops, on past the site for the 300-room [Colonial] hotel, by the esplanade, Fort Charlotte, past beautiful white beaches...We returned by way of the Queen's Staircase...and...passed the quite modern Bahama General Hospital...[arriving] back at the hotel ready for more daiquiri cocktails."

The economic depression that followed the end of Prohibition was ameliorated only by World War II, which brought thousands of British, Canadian and American servicemen to the islands, while many unemployed Bahamians were recruited as migrant labourers in the United States. The wartime Windsor Field airbase (named after the Duke of Windsor, who was the resident governor, during the war) eventually became Nassau International Airport, catering to thousands of new air travellers from Europe and North America.

"The postwar years witnessed a phenomenal growth in the tourist and banking industries," wrote Gail Saunders, "which was reflected in the building of new hotels and the expansion of Nassau to eastern, western and southern suburbs...[what] was once 'a quiet, sleepy, hollow sort of place' had become a rapidly expanding city."

Today, Nassau is a single, congested conurbation that sprawls over virtually the entire eighty-square-mile island of New Providence, now home to more than 220,000 people (out of a total population of 330,000). In the span of a few decades it has grown from a sparsely populated colonial backwater run by a handful of white shopkeepers and lawyers to the bustling capital of a new multiracial society.

Puritans, pirates, loyalists, slaves, liberated Africans, rum runners, tourists and financiers all contributed to the evolution of Nassau and the Bahamas over the past five hundred years. This sketchbook provides an artist's impression in watercolours and drawings of the city's varied past, linked to the buildings and neighbourhoods still here today, as well as a glimpse of some of the beautifully conserved historic settlements on nearby islands.

The preservation of this historic legacy is an important issue for the modern Bahamas. The Antiquities, Monuments and Museums Corporation was created by the government in 1998 to protect the diverse cultural experience of the islands. The Corporation operates four museums and maintains several historic forts on New Providence.

According to Bermuda archaeologist Ed Harris, "A hand and glove relationship exists between tourism and the preservation of the built environment. Tourism ensures the preservation of heritage and that heritage ensures the delight and abiding interest of the visitor. The fact is that sound tourism depends on the preservation of the historic environment."

A comprehensive Planning and Subdivision Act was passed in 2010 to address these, and similar, issues throughout the archipelago. It will hopefully "bring order to development and prohibit bad environmental and planning practices that have endured for far too long," proponents say.

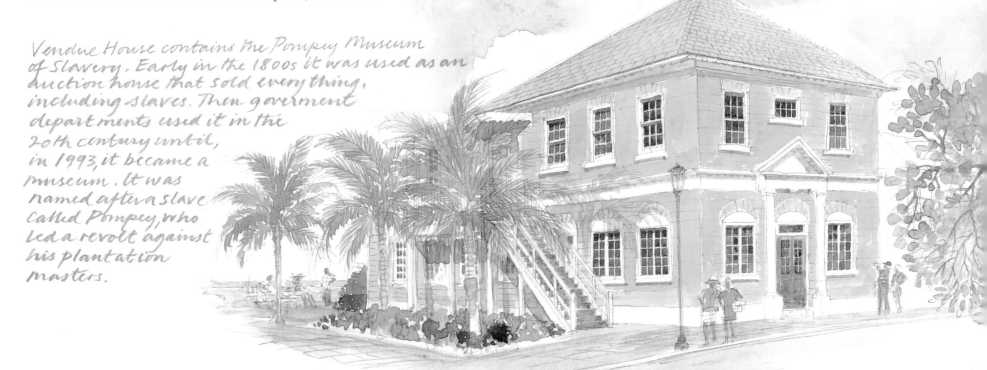

Vendue House contains the Pompey Museum of Slavery. Early in the 1800s it was used as an auction house that sold everything, including slaves. Then government departments used it in the 20th century until, in 1993, it became a museum. It was named after a slave called Pompey, who led a revolt against his plantation masters.

Central Nassau

"The capital...is the little town of Nassau, which hugs the hilly shore... There is but one tolerably regular street, or line of houses, which runs next to the water...A church, a goal and an assembly-house make up the public buildings of the town." – Johann David Schoepf, 1784

The original heart of Nassau is George Street, which runs from the governor's mansion on Mt Fitzwilliam to the Vendue House market (now the Pompey Museum) on the harbourfront.

To the west of the marketplace stood Fort Nassau, built in 1697 (and demolished in 1827). To the east was a small courthouse and gaol. And midway between Mt Fitzwilliam and the harbour is Christchurch Cathedral, which occupies the site of an earlier wooden church.

The first governor's mansion and the wooden church were both constructed in the 1720s, whilst Vendue House was erected in 1787 on the site of an earlier market.

The original ramshackle village of Charles Town had been destroyed by a Spanish invasion in 1684, after which Nassau became a loosely governed pirate republic. Governor Woodes Rogers arrived from England in 1718 with a small military force and orders to crack down on lawlessness, and by the 1720s stability had been restored.

When the German traveller Johann Schoepf described Nassau a year after the War of Independence ended, the colony was already experiencing an influx of thousands of American loyalists and their slaves. This migration was to change the Bahamas forever.

According to historian Maya Jasanoff, "All told more than 6,000 loyalists and their slaves arrived in the Bahamas, doubling the pre-war population and raising the ratio of black to white inhabitants from a little more than one to one, to two to one."

With the American influx, Nassau's centre of gravity moved eastward, and many of its modest wooden buildings were replaced by more imposing cut-stone structures. Foremost among these were the public buildings facing Rawson Square (built in 1802), a reconstructed governor's mansion and the new Christchurch on George Street, which became a cathedral in 1861.

A plan of the town of Nassau drawn up in 1788 shows that nearly all of the streets still found between Victoria Avenue in the east and Augusta Street in the west were already in existence. Meanwhile, the slaves who arrived with the loyalists moved to quarters Over-the-Hill, with names like Grant's Town, Bain Town and Delancey Town.

Queen Victoria's statue was unveiled in 1905. It is a favourite photographic subject for tourists.

Parliament Square contains the 18th-century Public Buildings (where the House of Assembly and Senate are located) and also the statue of Queen Victoria. It was Victoria who, in 1861, declared the town of Nassau a city.

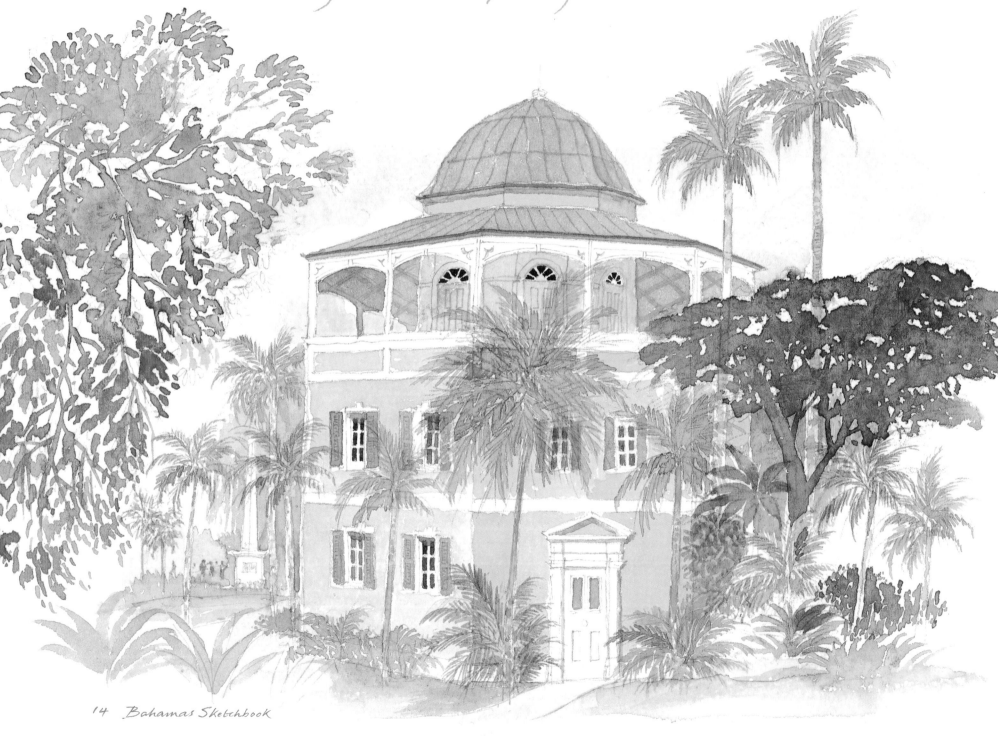

Nassau Public Library on Shirley Street was built as a prison from cut limestone blocks in 1798. The original prison cells were converted to book rooms in 1873. The library looks over the Garden of Remembrance.

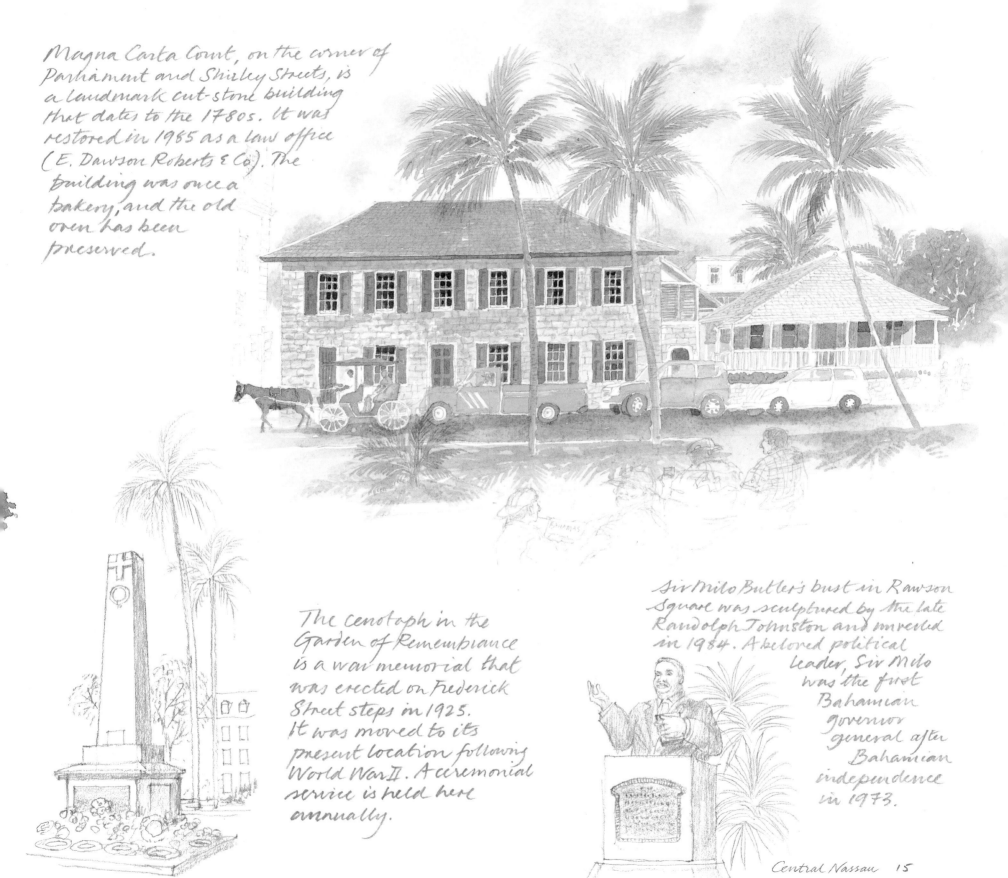

Magna Carta Court, on the corner of Parliament and Shirley Streets, is a landmark cut-stone building that dates to the 1780s. It was restored in 1985 as a law office (E. Dawson Roberts & Co). The building was once a bakery, and the old oven has been preserved.

The cenotaph in the Garden of Remembrance is a war memorial that was erected on Frederick Street steps in 1925. It was moved to its present location following World War II. A ceremonial service is held here annually.

Sir Milo Butler's bust in Rawson Square was sculptured by the late Randolph Johnston and unveiled in 1984. A beloved political leader, Sir Milo was the first Bahamian governor general after Bahamian independence in 1973.

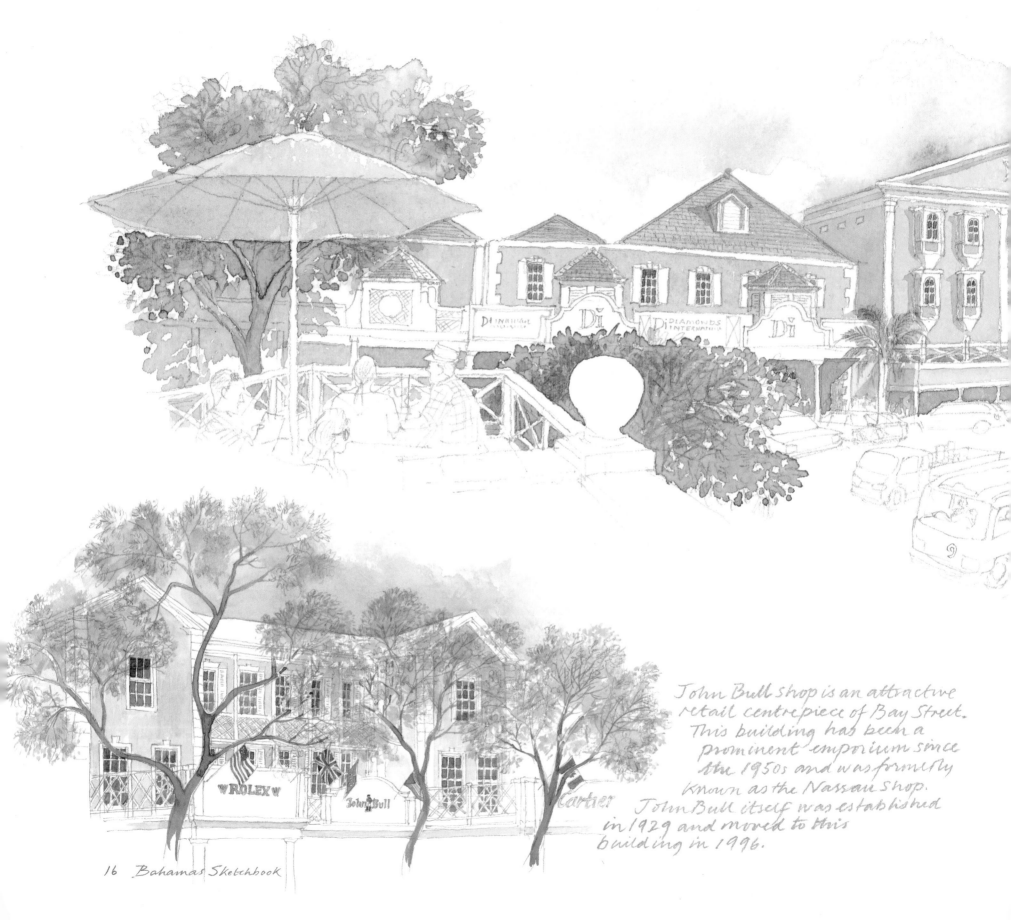

John Bull shop is an attractive
retail centrepiece of Bay Street.
This building has been a
prominent emporium since
the 1950s and was formerly
known as the Nassau Shop.
John Bull itself was established
in 1929 and moved to this
building in 1996.

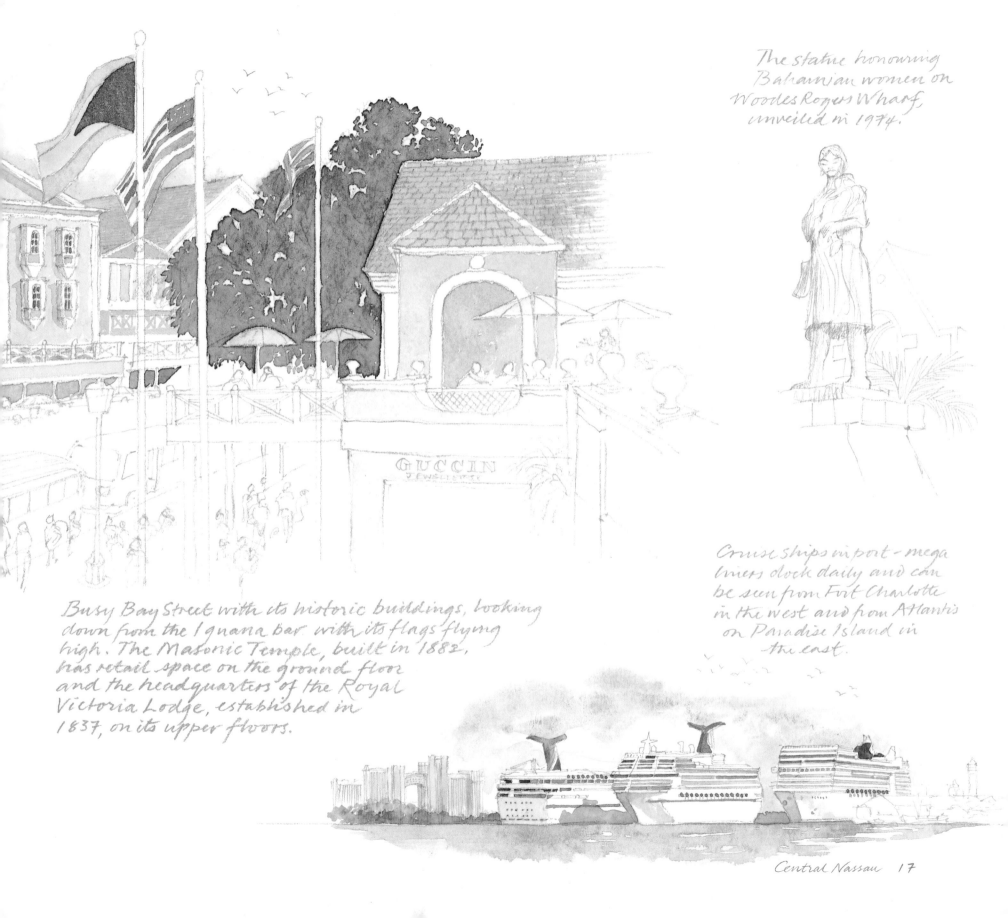

The statue honouring Bahamian women on Woodes Rogers Wharf, unveiled in 1974.

Cruise ships in port - mega liners dock daily and can be seen from Fort Charlotte in the west and from Atlantis on Paradise Island in the east.

Busy Bay Street with its historic buildings, looking down from the Iguana bar with its flags flying high. The Masonic Temple, built in 1882, has retail space on the ground floor and the headquarters of the Royal Victoria Lodge, established in 1837, on its upper floors.

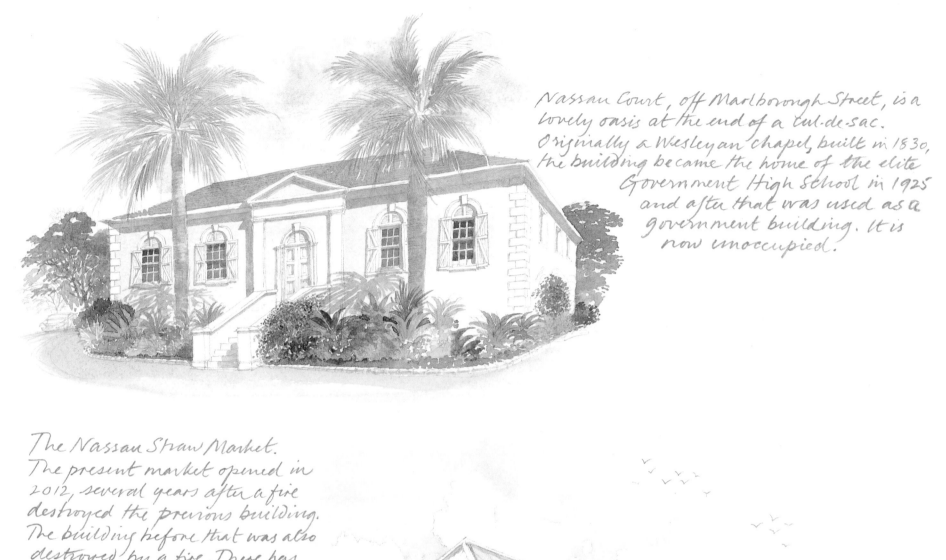

Nassau Court, off Marlborough Street, is a lovely oasis at the end of a cul-de-sac. Originally a Wesleyan chapel, built in 1830, the building became the home of the elite Government High School in 1925 and after that was used as a government building. It is now unoccupied.

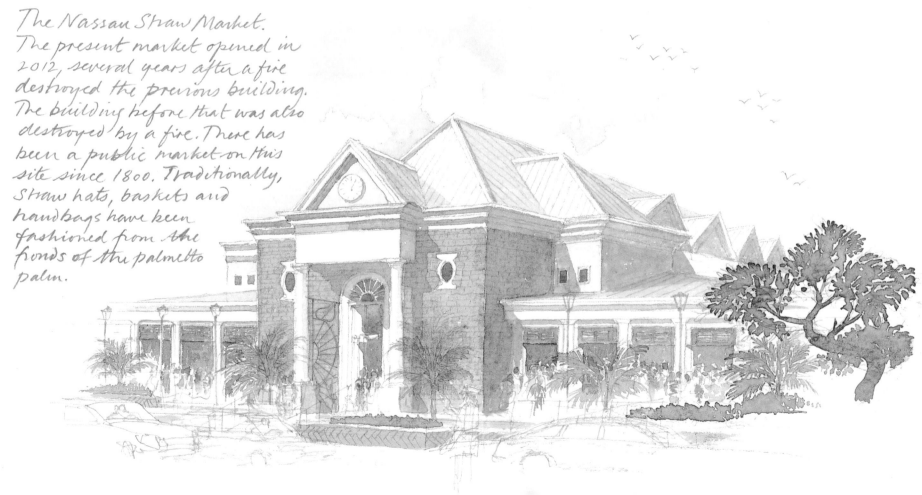

The Nassau Straw Market. The present market opened in 2012, several years after a fire destroyed the previous building. The building before that was also destroyed by a fire. There has been a public market on this site since 1800. Traditionally, straw hats, baskets and handbags have been fashioned from the fronds of the palmetto palm.

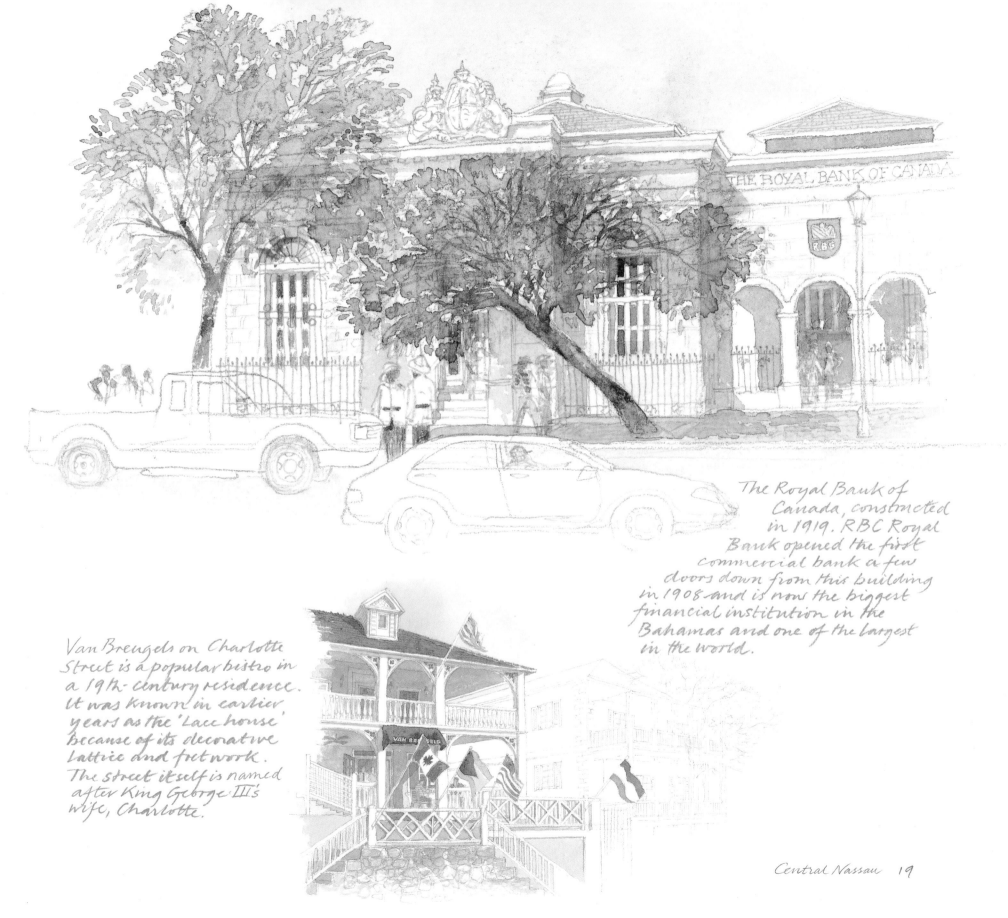

The Royal Bank of Canada, constructed in 1919. RBC Royal Bank opened the first commercial bank a few doors down from this building in 1908 and is now the biggest financial institution in the Bahamas and one of the largest in the world.

Van Breugels on Charlotte Street is a popular bistro in a 19th-century residence. It was known in earlier years as the 'Lace house' because of its decorative lattice and fretwork. The street itself is named after King George III's wife, Charlotte.

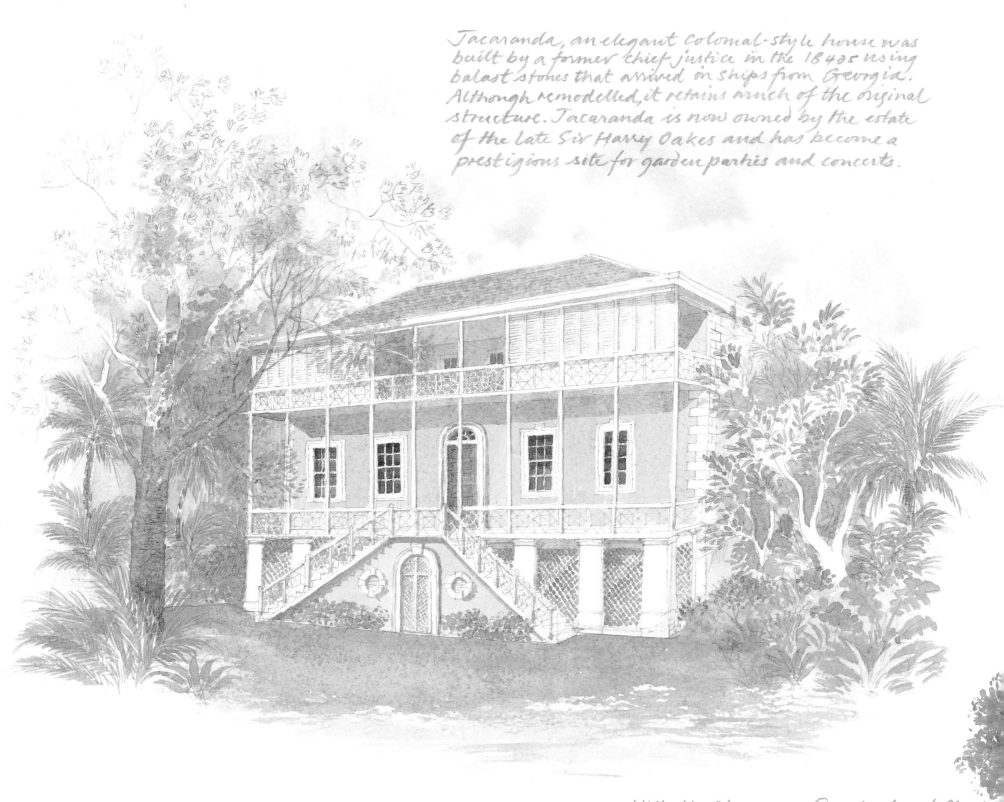

Jacaranda, an elegant Colonial-style house was
built by a former chief justice in the 1840s using
balast stones that arrived on ships from Georgia.
Although remodelled, it retains much of the original
structure. Jacaranda is now owned by the estate
of the late Sir Harry Oakes and has become a
prestigious site for garden parties and concerts.

Hillside Manor on Cumberland St.
This 1847 building (with the British Colonial
Hilton in the background) was restored in the
traditional blue by a travel agency.

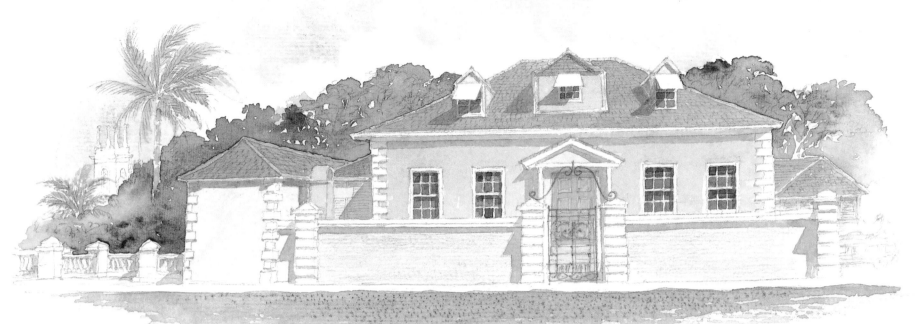

Hill crest House on East Hill Street, with the Presbyterian 'Kirk' seen
above the trees high on the hill. It was constructed in the mid-19th century
and once occupied by the founder of the Nassau Guardian (Edwin
Mosely). For years the Guardian was printed in this building.
And it has been beautifully restored by the law firm
of Alexion, Knowles and Co.

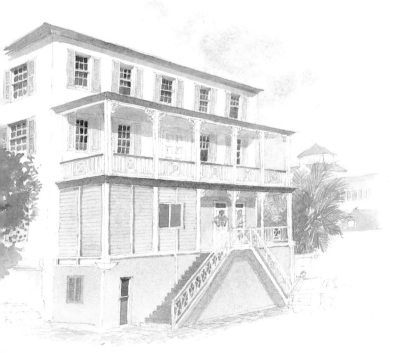

Christ Church Cathedral
on George Street is the official
axis of Nassau. Construction began in 1837 on the site
of an earlier church. In 1734 the island of New
Providence became the Parish of Christ Church,
and in 1861 the town of Nassau became a city
and Christ Church was consecrated as a cathedral.

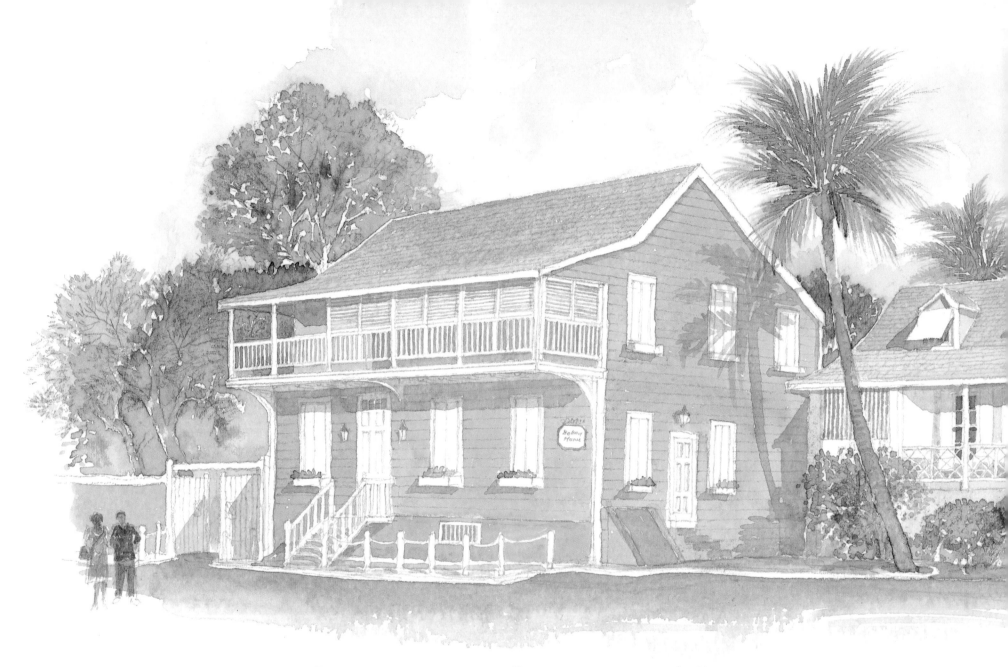

The beautiful pink Balcony House and its
neighbour Verandah House on Market Street
date to the 1790s. Both were restored by the
Central Bank of the Bahamas. Balcony House is
operated as a period museum by the Antiquities,
Monuments and Museums Corporation.

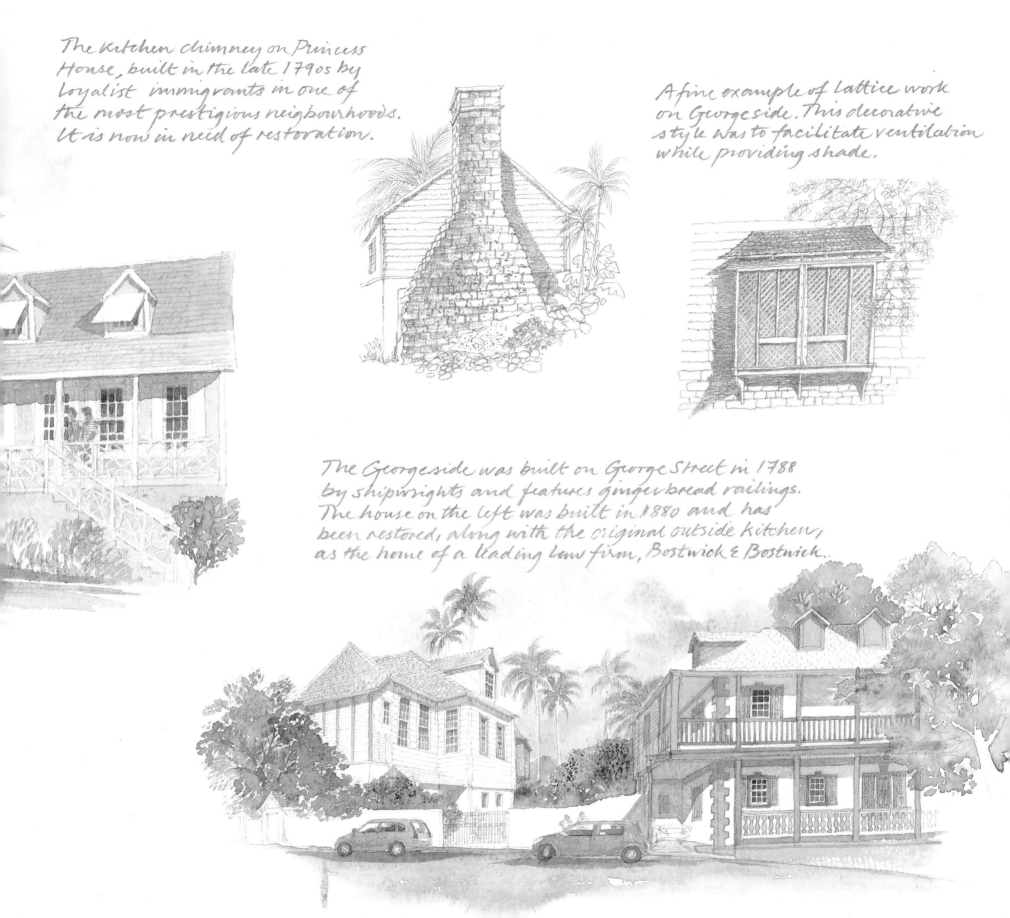

The kitchen chimney on Princess House, built in the late 1790s by Loyalist immigrants in one of the most prestigious neighbourhoods. It is now in need of restoration.

A fine example of lattice work on Georgeside. This decorative style was to facilitate ventilation while providing shade.

The Georgeside was built on George Street in 1788 by shipwrights and features gingerbread railings. The house on the left was built in 1880 and has been restored, along with the original outside kitchen, as the home of a leading law firm, Bostwick & Bostwick.

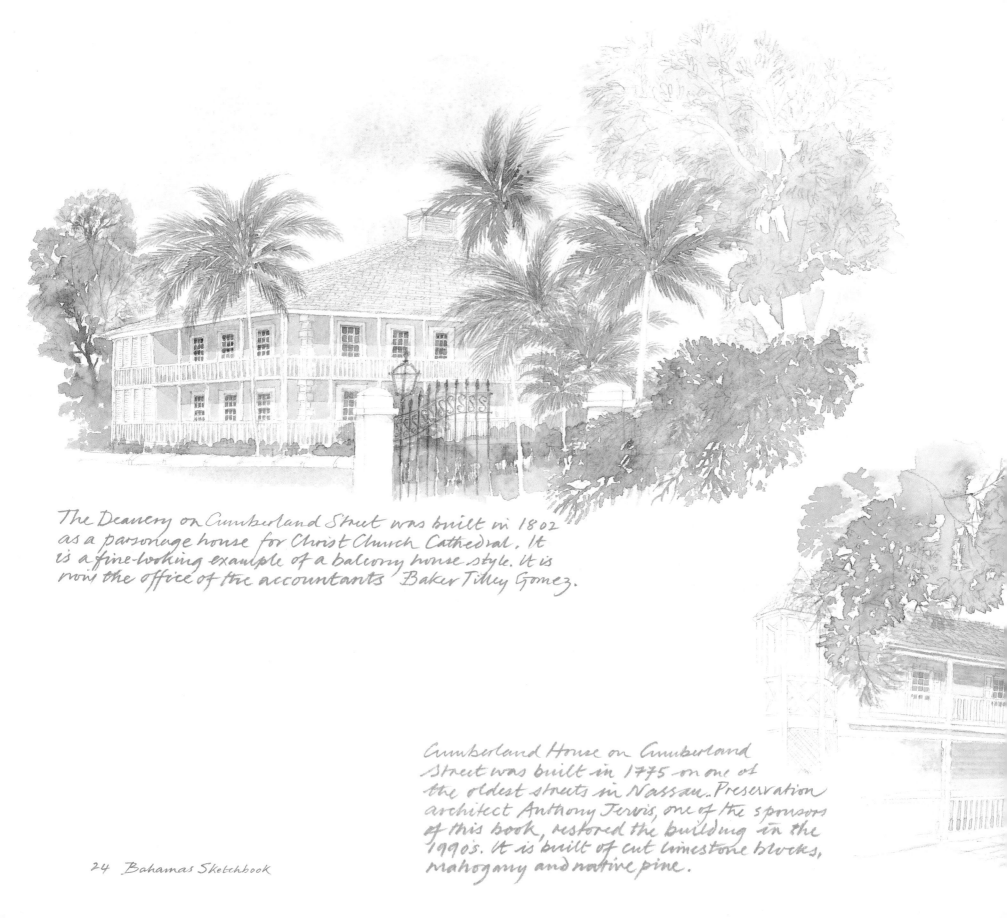

The Deanery on Cumberland Street was built in 1802 as a parsonage house for Christ Church Cathedral. It is a fine-looking example of a balcony house style. It is now the office of the accountants Baker Tilley Gomez.

Cumberland House on Cumberland Street was built in 1775 on one of the oldest streets in Nassau. Preservation architect Anthony Jervis, one of the sponsors of this book, restored the building in the 1990's. It is built of cut limestone blocks, mahogany and native pine.

Hillside House on Cumberland Street dates from the mid-1890s. It has been restored as the studio and gallery of well-known Bahamian artist Antonius Roberts and has a fine garden.

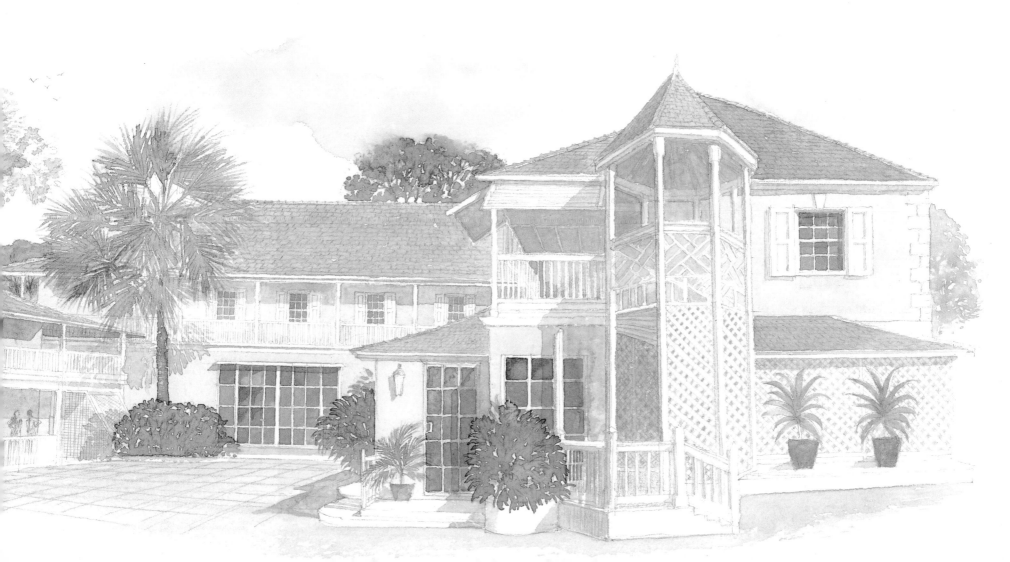

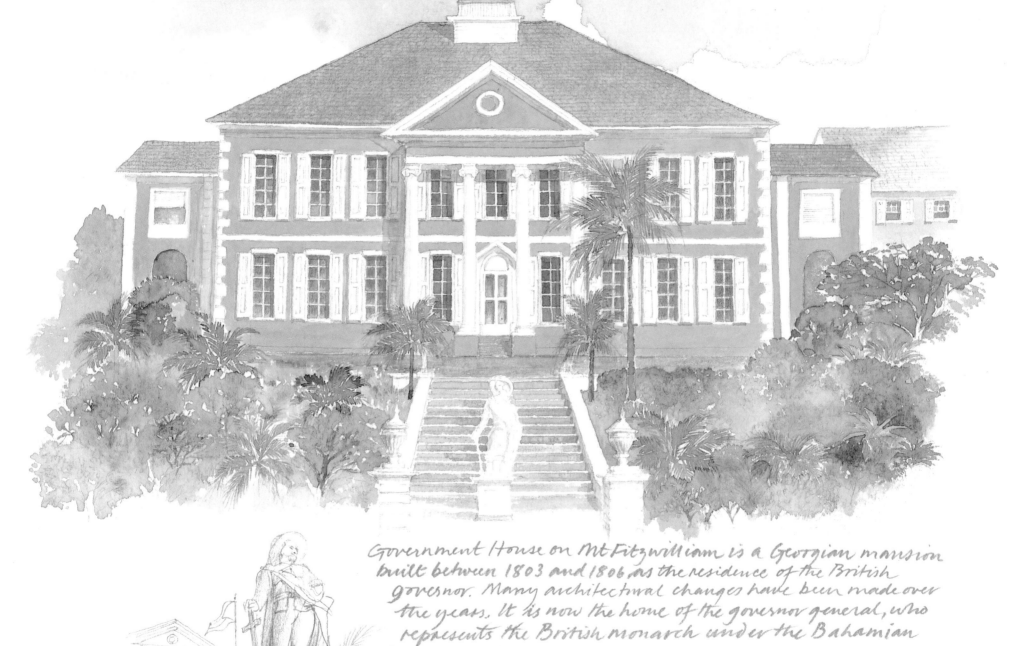

Government House on Mt Fitzwilliam is a Georgian mansion built between 1803 and 1806, as the residence of the British governor. Many architectural changes have been made over the years. It is now the home of the governor general, who represents the British monarch under the Bahamian constitution.

In the grounds stands a statue of Christopher Columbus, which reportedly was modelled by Washington Irving, a Columbus biographer. The twelve-foot-tall representation was installed by Governor James Carmichael-Smyth in 1830.

COLUMBUS
1492

St Andrew's Presbyterian Church on Princes Street – known as the Kirk – was built by the loyalists in 1810, although many renovations and additions have taken place since then. The congregation once included Nassau's super elite. It is now a popular venue for seasonal concerts.

Copulas are a feature of many of the big houses in Nassau.

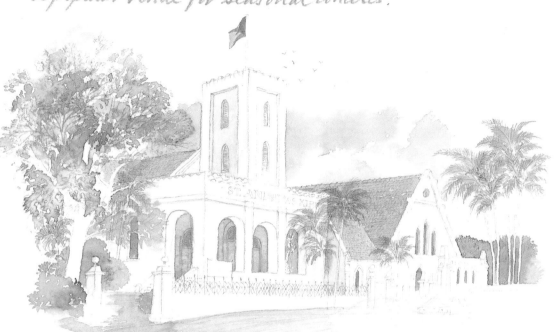

Apsley House on Frederick Street Steps dates to the 1840s and once housed the officers of the West India Regiment. In 1914 it was acquired by George Damianos Sr, a sponge merchant, and later became apartments. It is currently the headquarters of United European Bank.

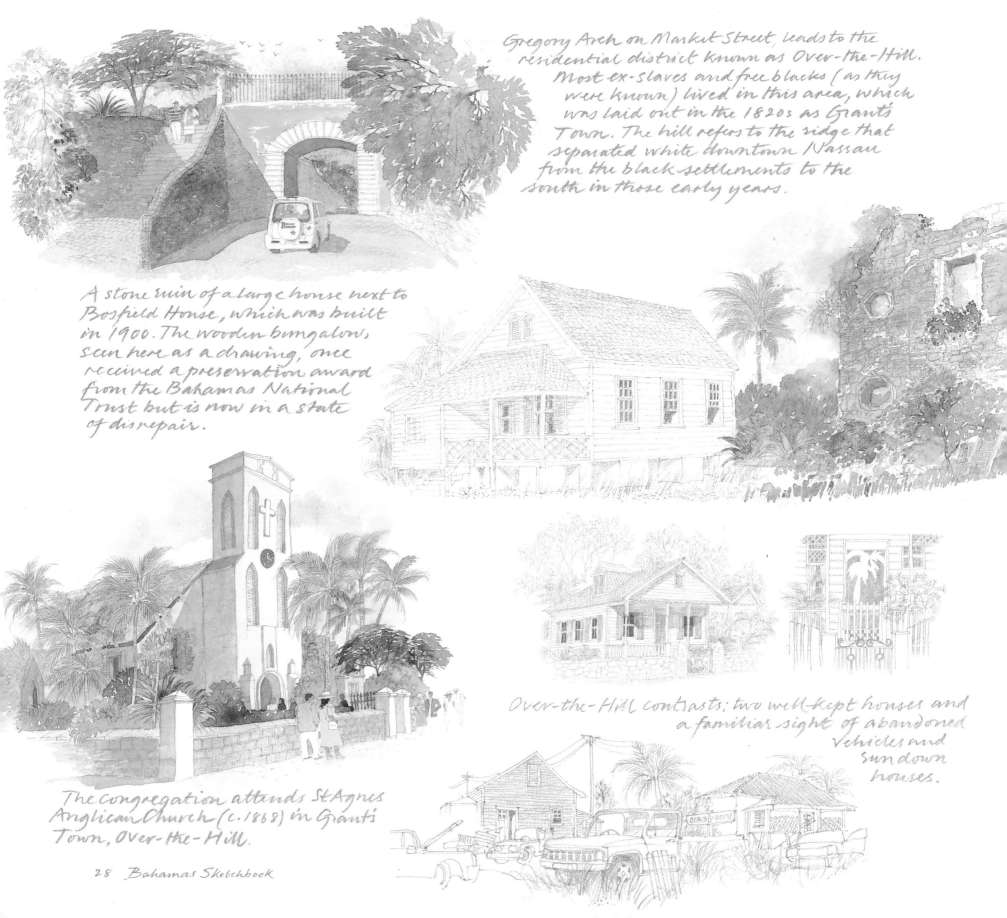

Gregory Arch on Market Street, leads to the residential district known as Over-the-Hill. Most ex-slaves and free blacks (as they were known) lived in this area, which was laid out in the 1820s as Grant's Town. The hill refers to the ridge that separated white downtown Nassau from the black settlements to the south in those early years.

A stone ruin of a large house next to Bosfield House, which was built in 1900. The wooden bungalow, seen here as a drawing, once received a preservation award from the Bahamas National Trust but is now in a state of disrepair.

The congregation attends St Agnes Anglican Church (c.1868) in Grant's Town, Over-the-Hill.

Over-the-Hill contrasts: two well-kept houses and a familiar sight of abandoned vehicles and sundown houses.

28 Bahamas Sketchbook

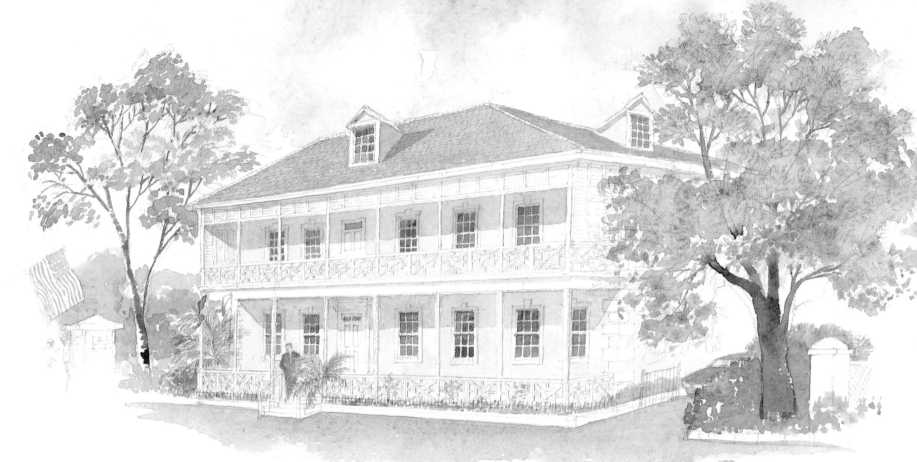

Devonshire House on Queen Street was
built in 1840 and has been beautifully
restored. It is now a private investment
bank, with a prestigious location
opposite the American Embassy.

At the end of Queen Street
stands a beautiful small
residence built in the
style of an English cottage
in 1804.

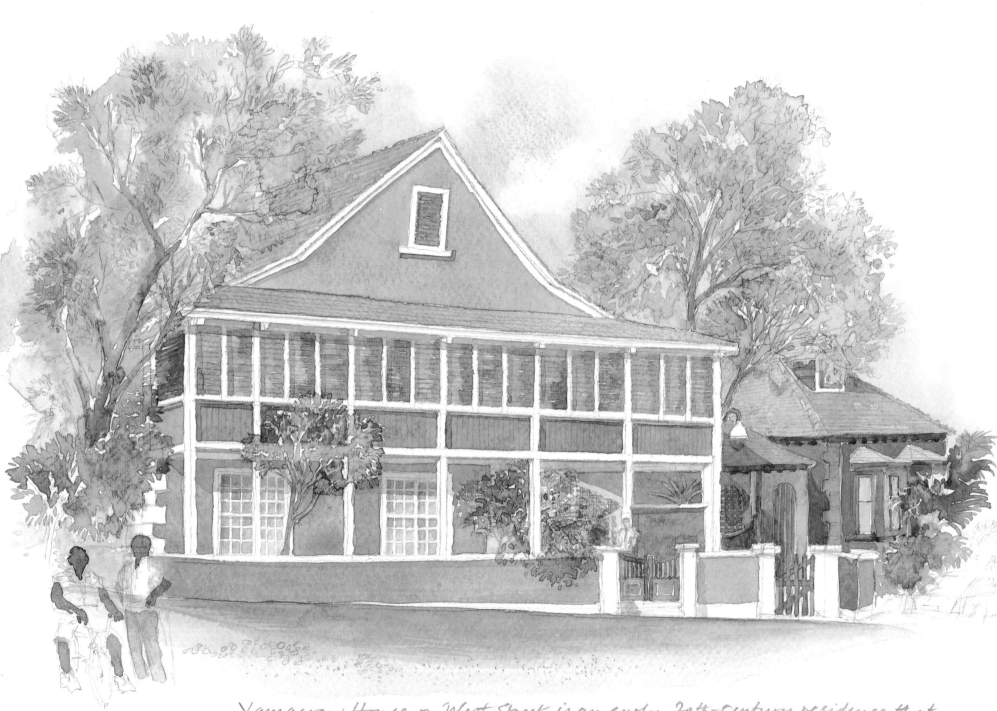

Yamacraw House on West Street is an early 20th-century residence that is now the architectural practice of preservation architect Anthony Jervis.

Marlborough House on Queen Street and Marlborough Street was built as a family home by Greek immigrants. It later became a dress shop and antique store. It is presently in good condition and is the office of a financial services provider.

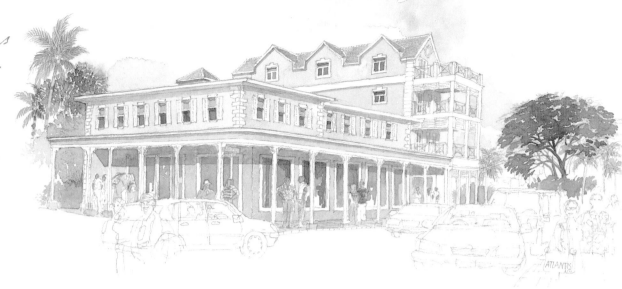

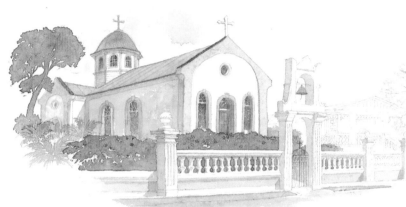

The Greek Orthodox Church was built in 1932 by Nassau's thriving Greek community. Many Greeks migrated here in the late 1800s and early 20th century to work in the sponge industry. The Church of the Annunciation, together with a beautifully decorated bungalow, is a colourful piece of Greek-style architecture in the heart of Nassau.

International House at the busy junction of West and Virginia streets dates to the early 1800s — a fine example of a classic balcony house. A brightly painted shop beyond named Kina Kina sells Balinese furniture.

Ranora House is one of the finest buildings on West Hill Street. In the mid-19th century it was a rectory for St Mary the Virgin Anglican Church on nearby Virginia Street and was called St Mary's villa. It is now a private home.

Graycliff Hotel is an 18th-century mansion that became Nassau's first inn in 1844. It was an officers' mess for the West India Regiment during the American Civil War, a guesthouse during the 1920s and a stately home until 1973 when Italian Chef Enrico Garzolli acquired it. He still operates it as a prestigious hotel and restaurant.

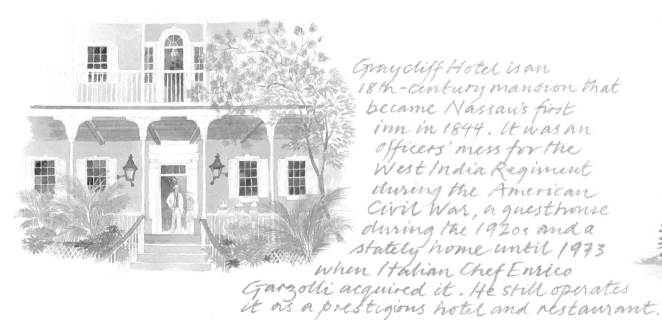

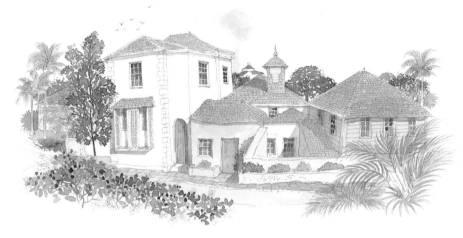

West Hill Street looking north from Graycliff Hotel towards the Fold (c.1840) and the Corner House (c.1870). The red tiled roof of the British Colonial Hilton can be seen beyond.

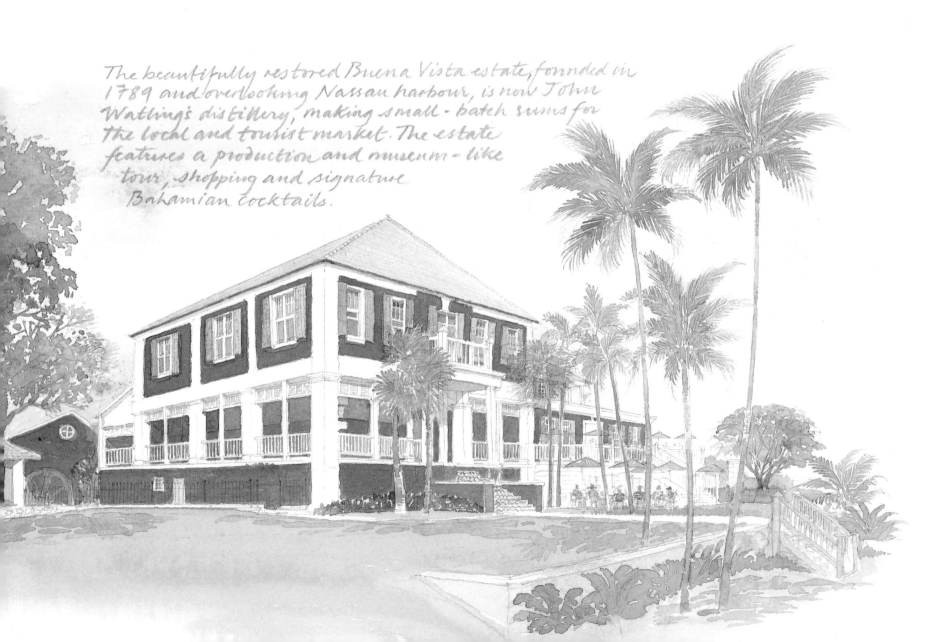

The beautifully restored Buena Vista estate, founded in 1789 and overlooking Nassau harbour, is now John Watling's distillery, making small-batch rums for the local and tourist market. The estate features a production and museum-like tour, shopping and signature Bahamian cocktails.

Going West

"The main thoroughfare and principal business street is Bay Street, running parallel to the water...A short walk to the west brings us out of the town. The roads and gardens are bordered with walls of coral rock, plastered all over or often on top only. In the parks and gardens and planted along the streets are cocoanut-palms, almond trees with their dark green glossy leaves, Spanish cedars, the sand-box tree, and the silk-cotton tree or ceiba, with its spreading horizontal branches and buttressed trunk." – John Northrup, 1910

Between West Street and the British Colonial Hotel lies a neighbourhood that spans more than three centuries of history – from the waterfront site of 17th-century Fort Nassau, the 19th-century West India Regiment barracks and the 20th-century Colonial Hotel to the imposing Villa Doyle mansion, built in the 1860s and now beautifully transformed into the National Art Gallery of the Bahamas.

Many Greek families settled in the area of Virginia Street in the late 19th and early 20th century. They came originally as sponge merchants and later diversified into shopkeepers, restaurateurs and professionals. They built the Greek Orthodox Church on West Street in 1932 and are now a thriving minority community.

Just west of this historic neighbourhood is Fort Charlotte, built by Lord Dunmore, the former British governor of Virginia in the late 1700s. Clifford Park on the fort's northern flank has been the site for many national events, most notably the 1973 independence celebrations.

Further to the west is the resort area known as Cable Beach, where the first undersea telecoms cable came ashore in the late 19th century. Today, this area is being redeveloped by Chinese and British interests as an upscale "riviera-style" resort known as Baha Mar. The Hobby Horse Hall plantation once occupied part of this land.

At the westernmost tip of the island lies Lyford Cay, a former mangrove creek that was transformed into the most exclusive residential enclave in the Bahamas by a Canadian investor in the 1950s.

The St Francis Xavier Cathedral was the first Roman Catholic church built in the Bahamas (c. 1885). It was consecrated by the Archbishop of New York in 1887.

Villa Doyle was built in the 1860s by a former chief justice. The southern two-storey section was added in the 1920s. The once derelict mansion was restored as the National Art Gallery over a period of seven years in the 1990s and opened to the public in the early 2000s.

The D'Aguilar Art Gallery, established by the late collector Vincent D'Aguilar occupies this 19th-century home on Virginia Street. The D'Aguilar Art Foundation is one of the sponsors of this book and holds regular exhibitions in this well-restored building.

ART FOUNDATION

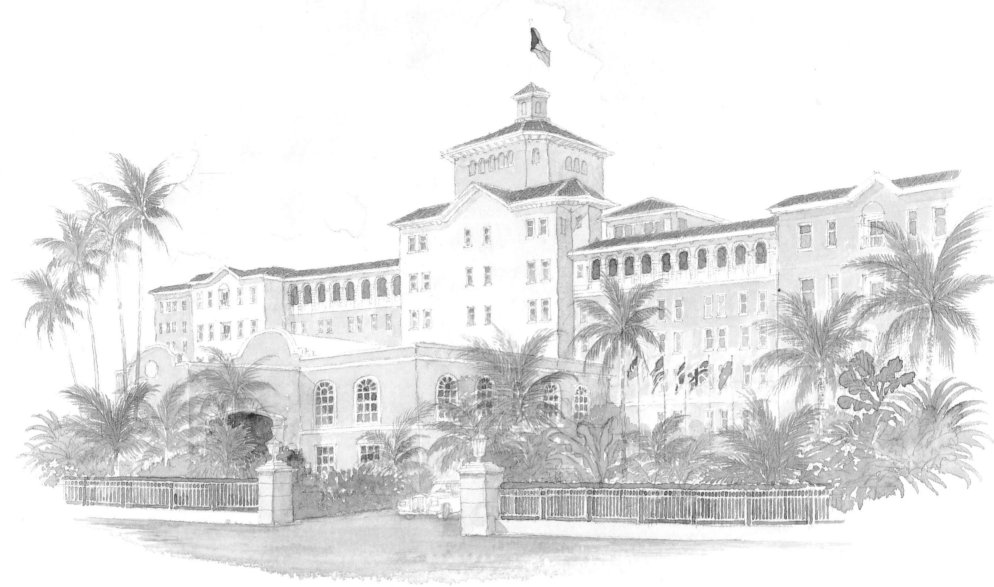

The British Colonial Hilton on Bay Street has an interesting history. It was built on the site of Fort Nassau (c.1695). An earlier colonial hotel built by the American railroad magnate Henry Flagler in 1900 burnt down in 1922. The new Colonial opened in 1923. The late Sir Harry Oakes purchased it in 1939 and named it the British Colonial Hotel. In the 1970s the Oakes family sold it and the main building was eventually closed. New owners undertook a multi-million dollar restoration and reopened in 1999 as the British Colonial Hilton.

The statue of Woodes Rogers stands outside the British Colonial Hilton. He was the first royal governor of the islands (1718-1721) He was sent by the British to crack down on the pirates.

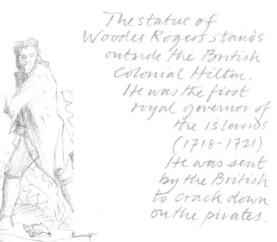

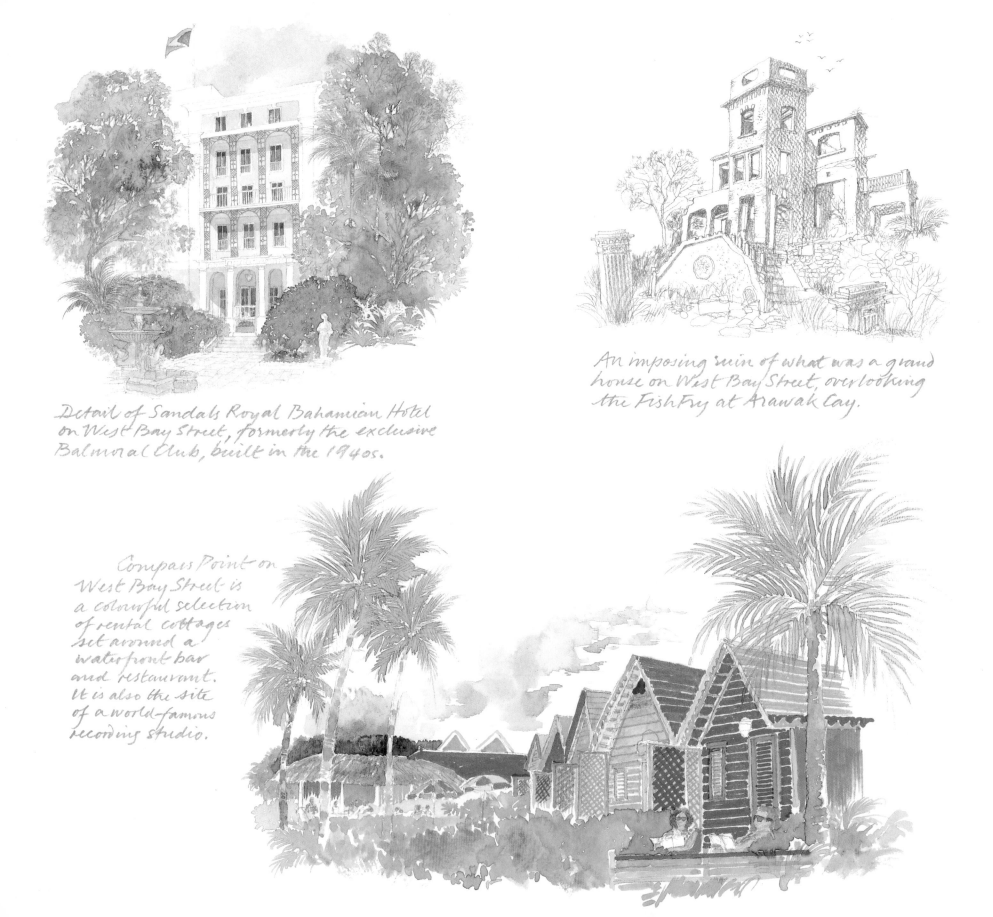

Detail of Sandals Royal Bahamian Hotel on West Bay Street, formerly the exclusive Balmoral Club, built in the 1940s.

An imposing ruin of what was a grand house on West Bay Street, overlooking the Fish Fry at Arawak Cay.

Compass Point on West Bay Street is a colourful selection of rental cottages set around a waterfront bar and restaurant. It is also the site of a world-famous recording studio.

Terra Nova, built on the shore in 1977 and with stunning views of the sea. With its very Spanish style one could be in the Mediterranean.

Far Niente was designed in the style of a French chateau in the 1990s. Its grounds contain a spectacular Romanesque pool leading to a grand gazebo.

Cronest is a family house designed by
Henry Melich and is now where his daughter
lives with her husband and children.

Windsong is another example
of a little gazebo tucked away
amongst bushes and flowers.

Henry Melich was a prolific architect
who came to the Bahamas in 1954. His
work is found all over the islands in
quite different styles, some of which
are on these pages.

Paco Flora was built in 1995.
It has a fine garden of flowers,
which adds to the charm of
this well-proportioned house.
Note the Bahamian influence
of the copola.

Cá Liza is an award-winning Palladian masterpiece that is covered in Caribbean limestone and gazes over a beach and the sea. The design marries the architecture of the Palladian villas in the Veneto with a local Bahamian interpretation. Thus, the top shutters and louvers blend with the canonically correct architectural details, symmetrical floor plan and proportions of the great master Andrea Palladio.

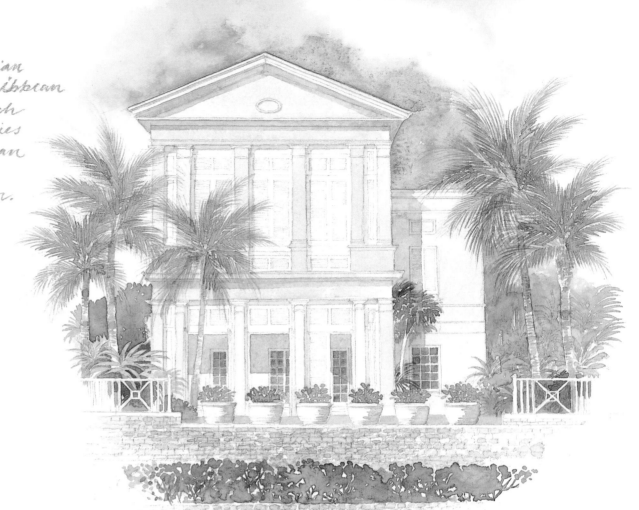

Hope Hill, designed by architect Henry Melich sits on a ridge with its back to the sun, capturing the light of an artist's studio. The openings and verandah work with the natural vegetation to provide a cooling effect on the adjacent rooms. The current owners have restored the house in the spirit of Oliver Messel.

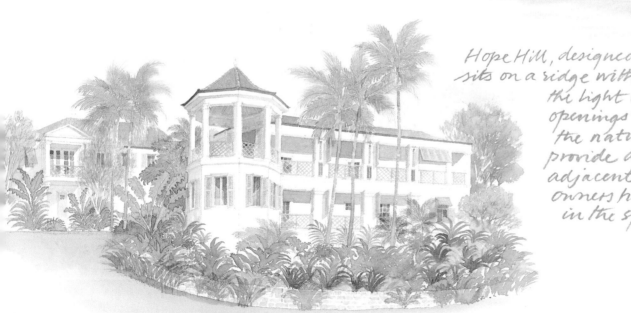

Old Fort's name refers to a building that dates to the early 1700s. It was converted to a sisal plantation around 1800. Later, in the 1920s, it was transformed into a winter residence by an American. Finally, it was restored in 2000 by the New Providence Development Company as a club house for the 320-acre upmarket residential community located there.

Lyford Cay Club, one of the sponsors of this book, is the centrepiece of Nassau's wealthiest and most exclusive gated community. It was developed in the late 1950s by Canadian investor E.P. Taylor.

Looking East

"In Bay Street to the east of the public buildings lie stores and offices of various sorts interspersed with dwelling houses. Wide and well-kept streets run inland to the south or give at intervals along various wharves that line the northern shore…Outside the city…are various country houses used as summer resorts; and frequently let to visitors." – George Northcroft, Sketches of Summerland, *1900*

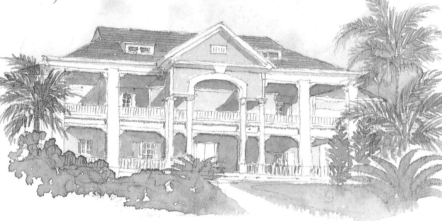

The eastern district of Nassau began to develop after the arrival of the loyalists in the late 18th century. Many fine residences were built on the ridge overlooking Shirley Street east of the public buildings.

These included Addington House, former residence of the Anglican Bishop (c. 1860) and later the Collins mansion (c. 1920) on the former Centreville estate. This building is now owned by the Antiquities, Monuments and Museums Corporation, which is in the process of restoring it.

In between Bay Street and Shirley Street, running east from Victoria Avenue, is Dowdeswell Street (in earlier times also known as Middle Road for obvious reasons). This low-rise neighbourhood retains many middle class 19th-century homes, most now re-purposed as shops or office buildings.

Dowdeswell Street ends at the green space known as Malcolm's Park, also called the Eastern Parade. The former Pan Am sea plane terminal building is on the waterfront just north of the park.

The first US Mail flight to Nassau departed from Pan Am Field in Miami in 1929. Fares were only $35 at the time.

The area just east of St Matthews Church is a former marshy area still known as the Pond, but now occupied by low-income homes. From here, East Bay Street extends along the harbour to 18th-century Fort Montagu. This stretch of road was originally all residential but is now mostly commercial, punctuated by busy marinas and boatyards.

The 1920s vintage Montagu Beach Hotel was demolished in the 1970s, and much of this area is now a public park, adjacent to a few high-rise financial office buildings. From the Royal Nassau Sailing Club, founded in the 1920s, East Bay Street runs into the posh Eastern Road, which extends all the way to the eastern tip of the island. This relatively high land was the preferred location for many affluent homeowners in the early to mid-20th century and is still one hundred per cent residential.

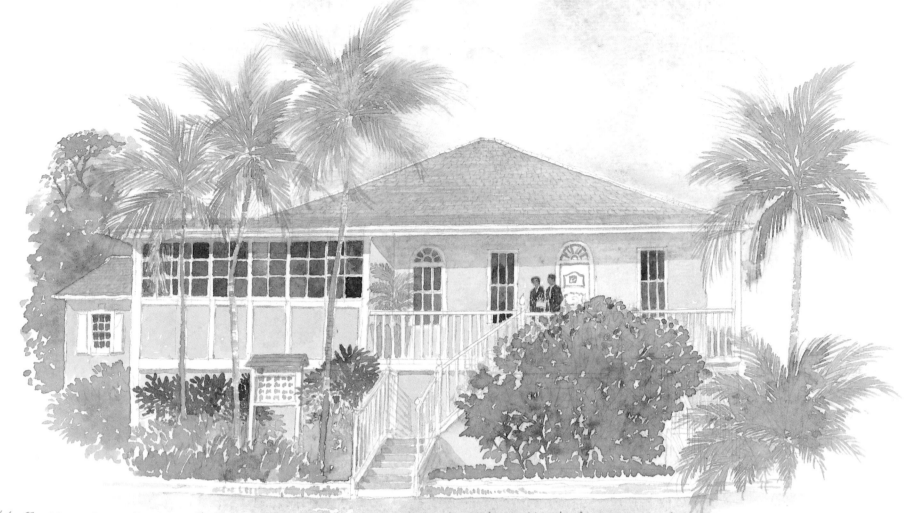

The H.G. Christie real estate office on East Street was built in the late 19th century and was once the home of a Greek sponge merchant named Esfakis.

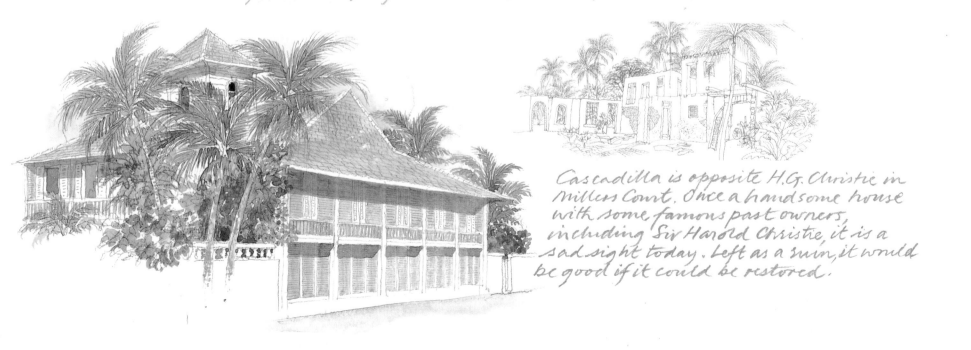

Cascadilla is opposite H.G. Christie in Millers Court. Once a handsome house with some famous past owners, including Sir Harold Christie, it is a sad sight today. Left as a ruin, it would be good if it could be restored.

Zode House on Victoria Avenue was
built in the 1890s of cut stone. It is a
fine house of that period with an
unusual staircase leading to the
entrance on the lower balcony.
It was restored in the mid-1990s
as a law office.

Red Roofs on East Bay Street, built in 1890. It is a beautiful example of a house with cupolas and porch, which is so cool in the Bahamas climate. Built from timber it features jalousies, railings and decorative posts made out of mahogany.

Villa Flora was built in the 1870s and restored by preservation architect Anthony Jervis.

The Carey House on Dowdeswell Street (c.1880) has unusual features, including ornate woodwork and sash windows.

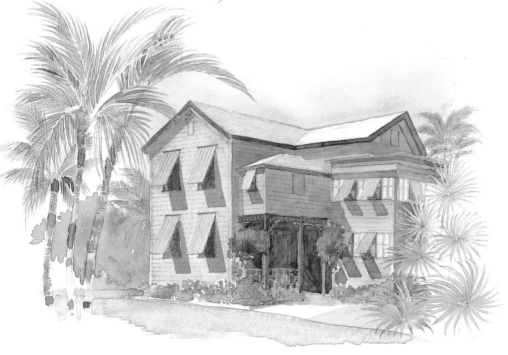

The Retreat on Village Road, headquarters of the Bahamas National Trust. Built about 100 years ago as the home of a colonial official and donated to the BNT in the 1980s, it is a unique green space that features one of the largest collections of palms in the world.

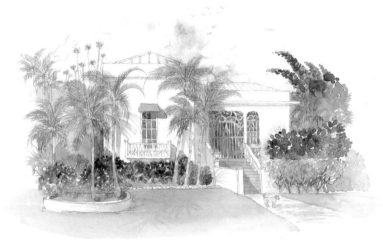

Number 10 Shirley Slope, built in the 1920s architectural style by a Canadian, George Murphy, in 1923.

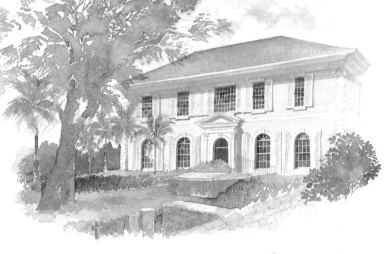

Ebenezer Methodist Church on Shirley Street was built between 1839 and 1841 on the site of an earlier chapel by Rev. William Turton, the first missionary to the Bahamas. The building, which is in a classical Georgian style, was fully restored after being heavily damaged in a 1929 hurricane.

The original St Matthew's Rectory dates from the early 1900s. It later became a convent and then the headquarters for the Templeton Theological Foundation.

St Matthew's Church on Shirley Street was built between 1800 and 1802 by loyalist Joseph Eve and is the oldest in the Bahamas. The steeple was added in 1816, but the original structure is unchanged.

The Royal Nassau Sailing Club on Eastern Road, looking towards Paradise Island across the bay, was founded in 1924 by members of the New York Yacht Club. Today, it is still a popular watering hole for Nassau's elite.

The Hermitage was built by the Governor Lord Dunmore in 1790 and had considerable land that stretched to the waterfront of Dicks Point. Over the years it has been extended and is now the residence of the Roman Catholic Bishop of Nassau.

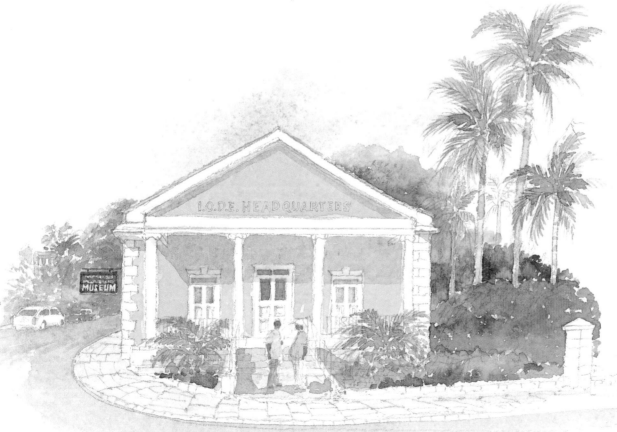

The I.O.D.E Hall on Shirley Street dates back to 1905 and was the headquarters of the Imperial Order of the Daughters of the Empire. It was donated to the Bahamas Historical Society in 1976, and is now the Society's headquarters, containing a museum showing the history of the Bahamas.

Designed by architect Sidney Neil, this residence was built in 1940 for
William B. Russell, the owner of the downtown Nassau store Stop-N-Stop, by
his father, Charles A. Russell, a carpenter previously employed at
Wilson City Lumber mill in Abaco, and was called "At Last". It was renovated
in the mid-1960s and again in 2004, when the property was acquired by
Dawn Davies, a sponsor of this book, with the oversight
of architect John Paine.

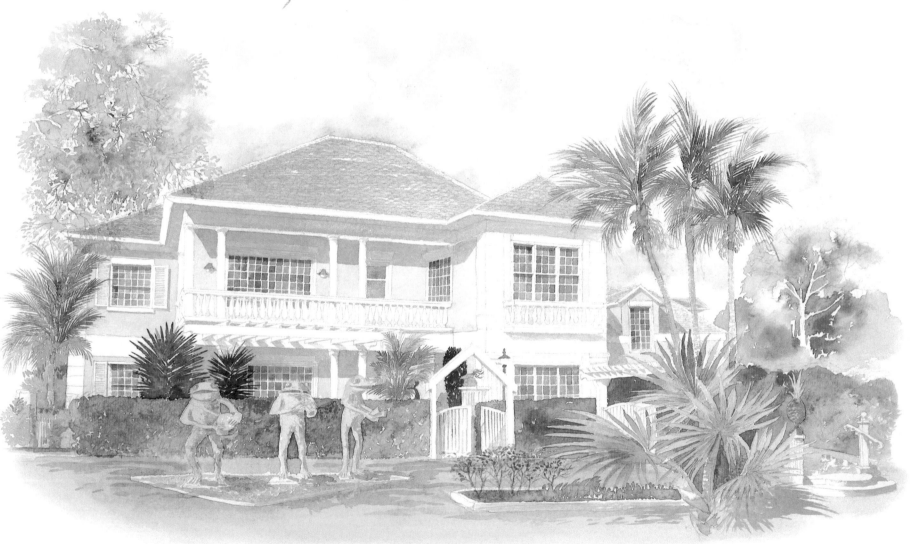

Mrs Davies changed the name to "Callaloo" (a tropical plant with spinach-
like leaves widely used in Caribbean cooking), an indication of her intent
to focus on the development of the garden, with trees, flowering plants
and sculpture, such as the work "Frogarooers" that's in this painting's foreground.

Paradise Island

The "island which makes the harbour" was originally commonage land for the early settlers of New Providence. In 1698 Hog Island, as it was then known, was acquired for the sum of fifty pounds. It is now one of the most valuable pieces of real estate in the Caribbean.

The first lighthouse in the Bahamas was built on the western tip of Hog Island in 1816, where criminals were once hanged and displayed, and a shipyard was developed on the harbourside during the American Civil War to service Confederate blockade runners.

In the late 18th century there was a banqueting (or picnicking) house on the island. This was followed by the construction of "pleasure resorts" overlooking the northern beaches, which eventually led to the world-famous Paradise Beach complex, developed by a New Yorker named Frank Munson in the early 20th century.

Until the mid-20th century Hog Island was sparsely developed as a winter retreat for wealthy visitors. Most notably, a Swedish industrialist named Axel Wenner-Gren acquired a large estate in 1939 to build a mansion called Shangri-La.

In 1961, A & P Supermarket heir Huntington Hartford bought Wenner-Gren's estate for $9.5 million, Hog Island was renamed Paradise, and Shangri-La was redeveloped as the exclusive fifty-two-room Ocean Club, complete with a cloister built from the disassembled stones of a monastery that William Randolph Hearst had stored in a Florida warehouse.

Hartford's redevelopment included dredging part of the eastern end of the harbour to add forty-two acres opposite Fort Montagu. A golf course and later an airstrip were built on this reclaimed land, which is now part of the exclusive residential enclave known as Ocean Estates.

In 1966, as tourism boomed, the government dredged Nassau harbour to improve the cruise port, with most of the spoil used to create Arawak Cay and to create Lighthouse Beach on Paradise Island. This project was tied to the sale of Hartford's development to an American company, which later became Resorts International and included construction of the first bridge from Nassau to Paradise.

Improved access led to the construction of large modern hotels, which were eventually acquired by a South African investor named Sol Kerzner, who redeveloped the resort as Atlantis in the mid-1990s.

Detail of the Gazebo in the Versailles Gardens.

The Marina Village at Atlantis was developed by Kerzner International as a replica of a Bahamian out island settlement, featuring shops, restaurants and bars encircling an exclusive mega-yaht marina.

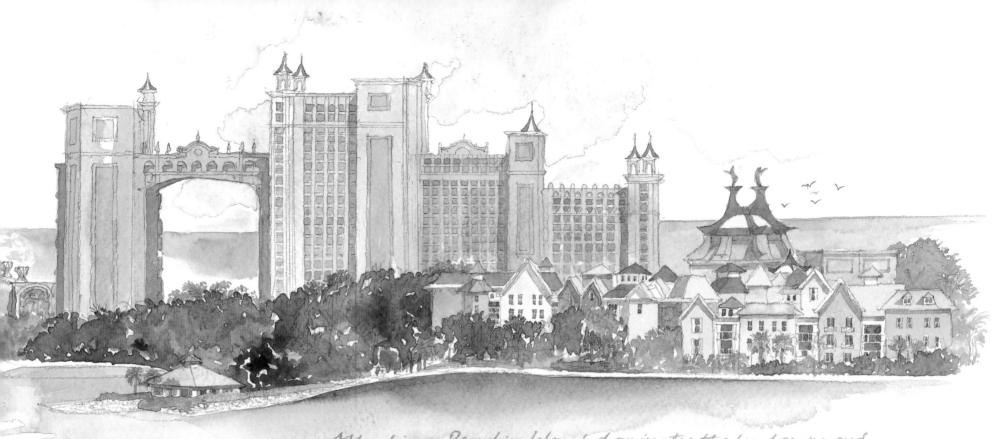

Atlantis on Paradise Island dominates the landscape and is a popular hotel and casino. The island has a fine golf course, spectacular beaches and grand private houses. It is linked to Nassau by two bridges.

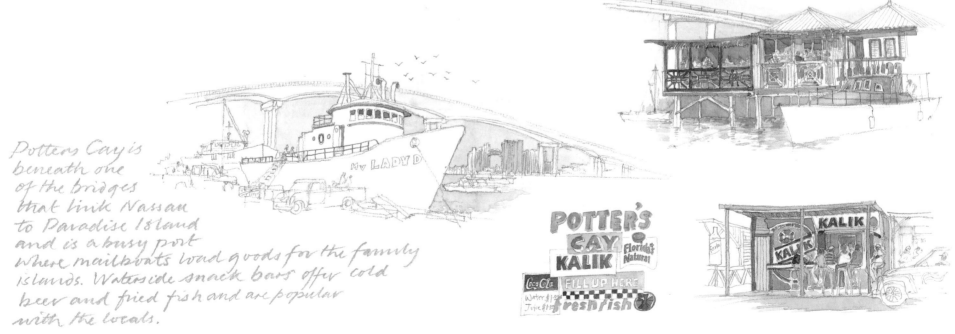

Potters Cay is beneath one of the bridges that link Nassau to Paradise Island and is a busy port where mailboats load goods for the family islands. Waterside snack bars offer cold beer and fried fish and are popular with the locals.

POTTER'S CAY
KALIK
Florida Natural
Coca-Cola
FILL UP HERE
Water $1⁰⁰
Juice $1²⁵
fresh fish 5¢

KALIK

The Ocean Club view — Swedish
industrialist Axel Werner-Gren's home —
was on this spot and called Shangri-La.
In 1959, Huntington Hartford acquired
the estate and built the original Ocean
Club, gracing the property with terraced
gardens, fountains and statuary
imported from Europe.

The property was purchased by
Atlantis developer Kerzner International
in 1994 and re-named the One & Only
Ocean Club in 2002.

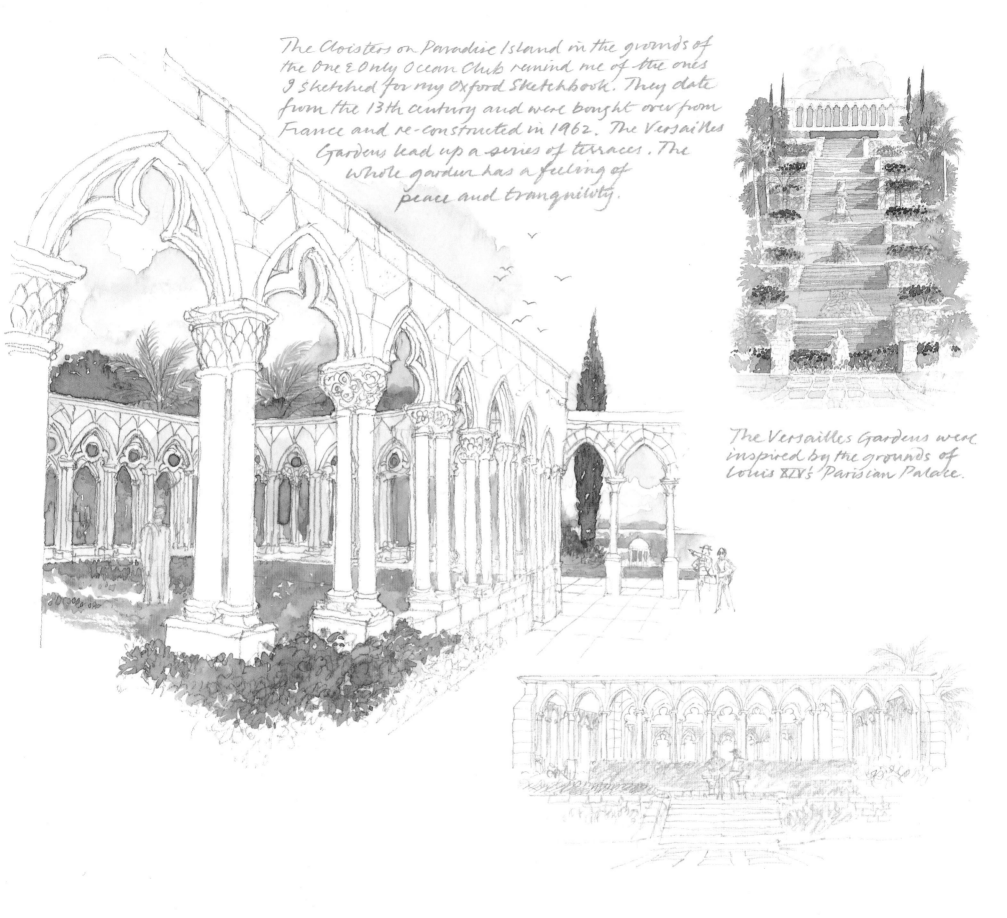

The Cloisters on Paradise Island in the grounds of
the One & Only Ocean Club remind me of the ones
I sketched for my Oxford Sketchbook. They date
from the 13th century and were bought over from
France and re-constructed in 1962. The Versailles
Gardens lead up a series of terraces. The
whole garden has a feeling of
peace and tranquility.

The Versailles Gardens were
inspired by the grounds of
Louis XIV's Parisian Palace.

Family Islands

After the demise of the plantation system in the mid-19th century, all of the Bahamian islands other than New Providence were largely undeveloped and used for subsistence farming and by fishing communities. They came to be known as the out islands.

They were supervised by a rudimentary system of local government consisting of a travelling district commissioner, who acted as both magistrate and governor of these tiny communities. After independence in 1973, the out islands came to be called the family islands in a spirit of national solidarity.

GRAND BAHAMA

In 1955 the government leased eighty square miles of wilderness for next to nothing to an American named Wallace Groves, who had been running a lumber operation on the island. In return, Groves converted uninhabited Hawksbill Creek into a deep-water port and carved a new township, named Freeport, out of the pine barren.

Groves' original land grant was later increased to about two hundred square miles, and the Hawksbill Creek Agreement created the Bahamas' second city. Grand Bahama had been sparsely settled by freed slaves after 1835, but today the island has a population of some fifty thousand.

SAN SALVADOR

Following the American War of Independence, land grants in the Bahamas were one of the ways the British compensated those colonials who had remained loyal to the king. Several thousand white settlers, free blacks (as they were known) and African slaves arrived in the islands in the late 1700s. They established short-lived plantations on several islands. About a dozen such estates operated on San Salvador from the late 1700s to the 1830s. Cockburn Town is named after a 19th-century governor of the Bahamas.

ABACO

Abaco was also uninhabited until the arrival of loyalists, free blacks and slaves from New York, Charleston and Florida in the late 1700s. Like Grand Bahama, Abaco was covered with dense pine forest, which was logged in the early 20th century.

The settlement of Hope Town on Elbow Cay is one of several seafaring communities established by American loyalists. The entire community descends from the family of a widow named Wyannie Malone, who emigrated from Charleston in the 1780s. Today, Hope Town makes its living from high-end tourism.

ELEUTHERA

The first European settlers of the Bahamas were seventy disaffected Bermudians who tried to establish a republican government on the island of Eleuthera in the mid-1600s. Many Bahamians are descended from those first migrants.

In fact, several years ago archaeologists discovered six of those Bermuda puritans

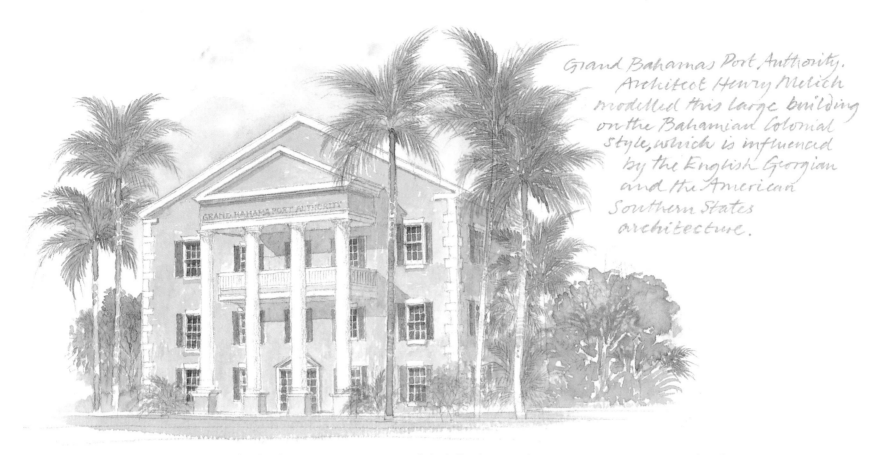

Grand Bahamas Port Authority. Architect Henry Melich modelled this large building on the Bahamian Colonial style, which is influenced by the English Georgian and the American Southern States architecture.

buried in shallow graves at Preacher's Cave on North Eleuthera. After being shipwrecked, they used the cave as a shelter, meeting place and cemetery. DNA evidence has confirmed the relationship between their remains and the present-day inhabitants of the island.

Residents in the prosperous fishing community of Spanish Wells, and the settlements of Harbour Island and Governor's Harbour all trace their roots back to the Eleutheran Adventurers. And all three were significant communities in these early years.

CAT ISLAND
Cat Island is located in the centre of the archipelago and features the country's highest point. Mt Alvernia (206 feet) is topped by a rustic monastery, known as the Hermitage, built by an American Franciscan monk in the 1940s. It was Father Jerome Hawes who

renamed the hill Alvernia after a site in Tuscany associated with St Francis of Assisi.

Several loyalist plantations were also established on Cat Island, but most plantation owners eventually left the southern islands to their former slaves. These people continued to eke out an existence through subsistence farming and fishing in relative isolation, until the expansion of tourism in the mid-20th century.

LONG ISLAND
Long Island is a green and pristine island, some eighty miles long. Christopher Columbus named a beach there after one of his ships (Cape Santa Maria). With four miles of pure white sand, it is one of the world's great beaches. Clarence Town, the capital, has two historic churches designed by Father Jerome Hawes. Ruins of old plantations abound from the days of slavery.

Eleuthera

Harbour Island was established in the 17th century by the Eleuthera Adventurers because of its fine natural harbour. The American Loyalists arrived around 1780, and they were the ones who built houses that were influenced by the New England architecture. The timber vernacular of all the islands is from this period, when alot of the buildings were built, many of which are still standing today.

HARBOUR ISLAND
Home Of Friendly People
~ Est 1650 ~

A classic influence from New England.

St John's Anglican Church (1768) is in beautiful condition and is one of the oldest churches in the Bahamas.

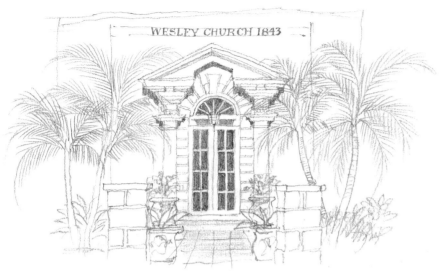

An ornate entrance to Wesley Church.

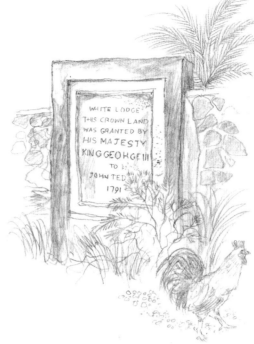

An old stone monument still on the wall bordering the land which was granted to the owner in 1791.

A fine view of Harbour Island, which was also known as Dunmore Town as the governor, Lord Dunmore, originally laid out the town in the late 18th century.

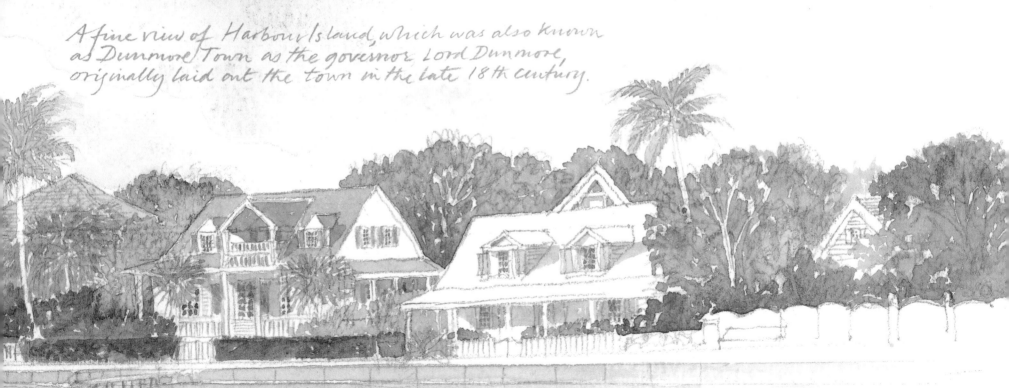

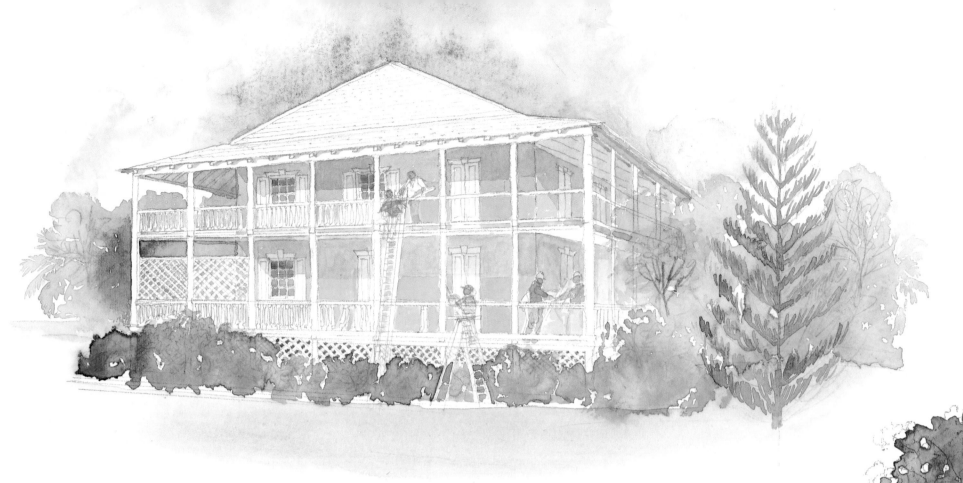

The commissioner's residence is situated
on a hill looking out to sea. It was built
in 1920. It is a classic balcony house,
and is seen here being restored in 2013,
to become a museum and an
information centre for Harbour
Island. Lord Dunmore built
the original house on the same
site as the present one whilst he
was governor general of the
Bahamas 1786-1797.

Built in 1848 the
Pyfrom House is one of
the finest and oldest
clapboard houses in
Governor's Harbour.

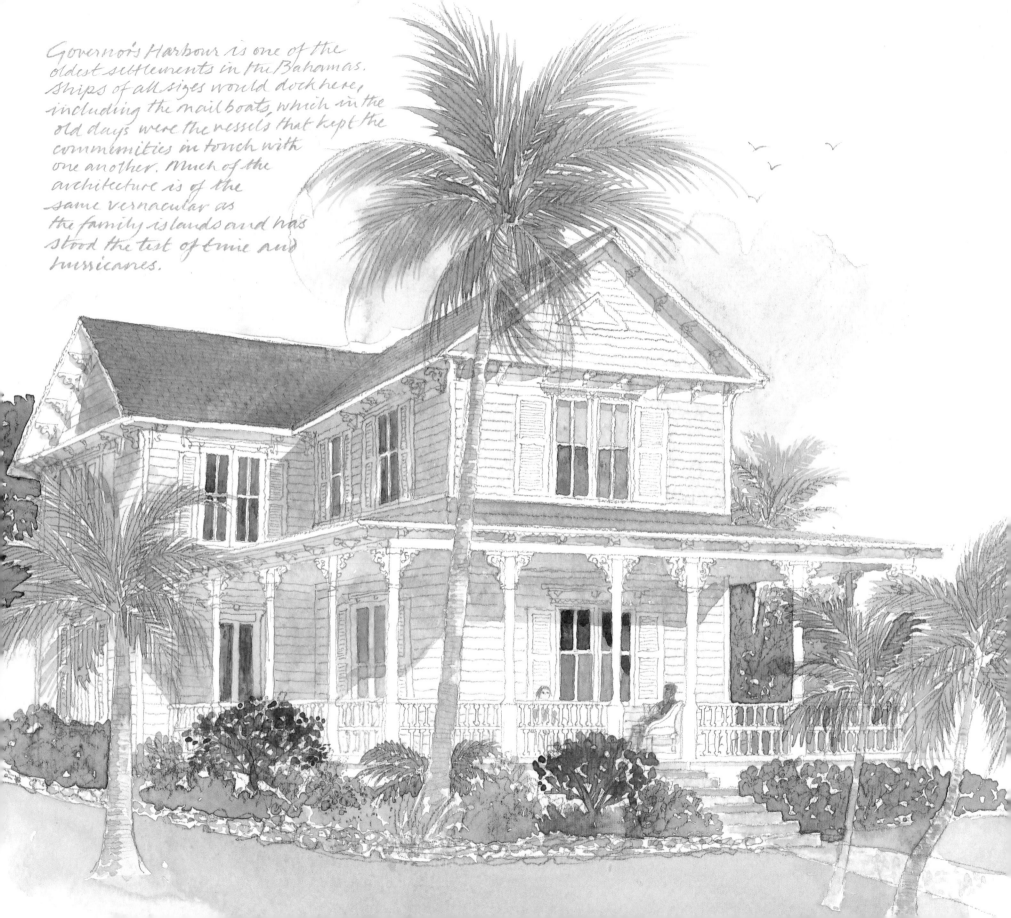

Governor's Harbour is one of the oldest settlements in the Bahamas. Ships of all sizes would dock here, including the mail boats, which in the old days were the vessels that kept the communities in touch with one another. Much of the architecture is of the same vernacular as the family islands and has stood the test of time and hurricanes.

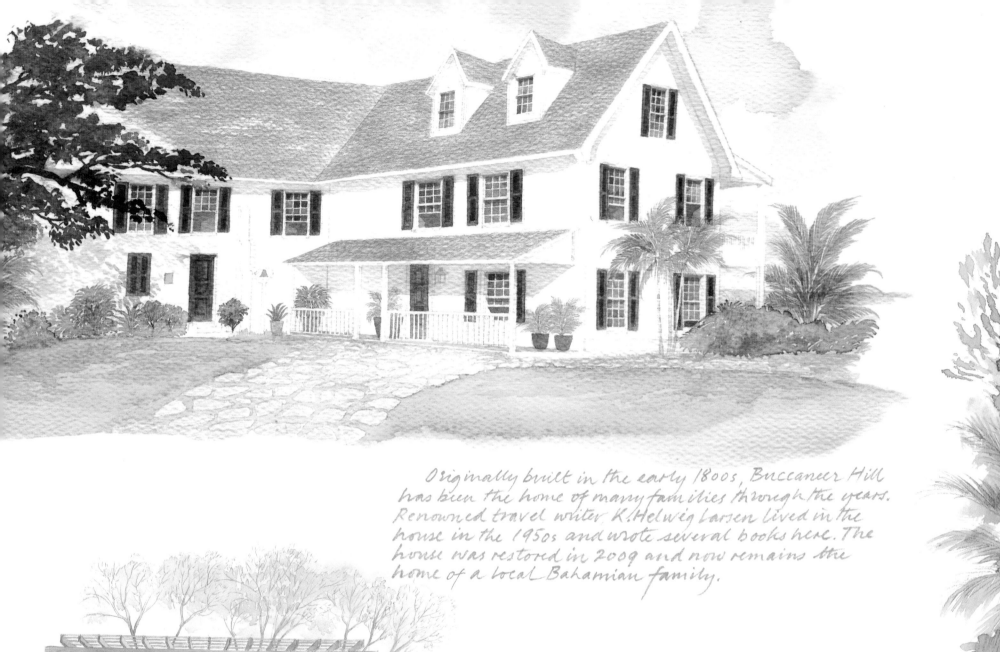

Originally built in the early 1800s, Buccaneer Hill has been the home of many families through the years. Renowned travel writer K. Helweg Larsen lived in the house in the 1950s and wrote several books here. The house was restored in 2009 and now remains the home of a local Bahamian family.

The entrance to the Leon Levy Native Plant Preserve on Banks Road near Governor's Harbour. It protects 25 acres of coppice and red mangrove forest. The preserve is dedicated to the conservation of native species and to the research of Bahamian bush medicine. Open to the public, the preserve is linked to the Bahamas National Trust and holds educational group tours.

Haynes Library was built in 1887 and served the community of Governor's Harbour until the 1990s, when it was closed. Local residents in opposition to its closure raised the money to restore this beautiful and useful building. It now offers a book library, internet access and research facilities.

HAYNES LIBRARY 1897

HAYNES LIBRARY

Abaco

The Wyannie Malone Historical Museum is named after one of the first settlers of Hope Town. It is supported by volunteers. It is one of the original houses, beautifully restored, and has a fine collection of artifacts which reflect the history of the town.

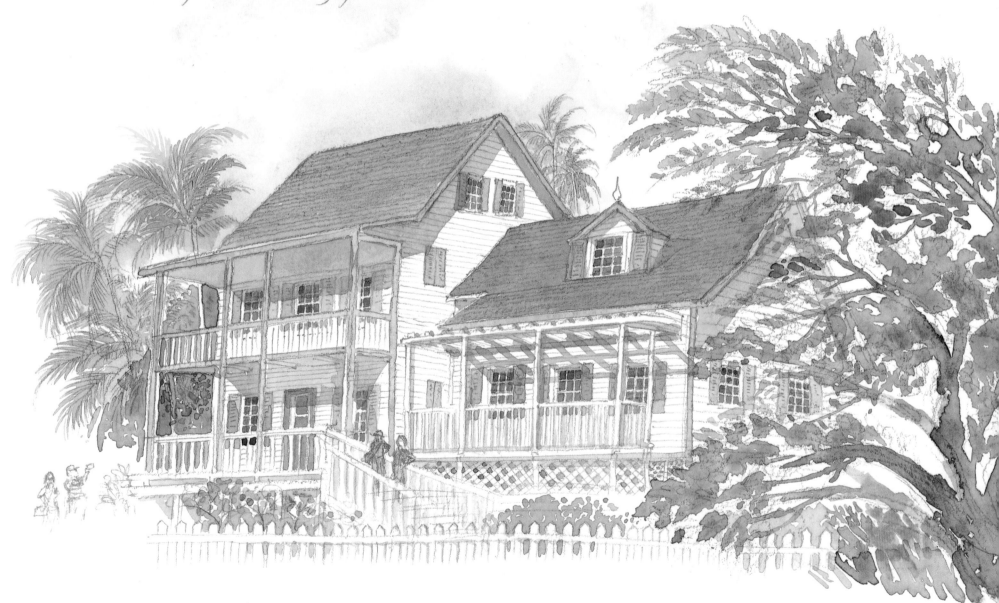

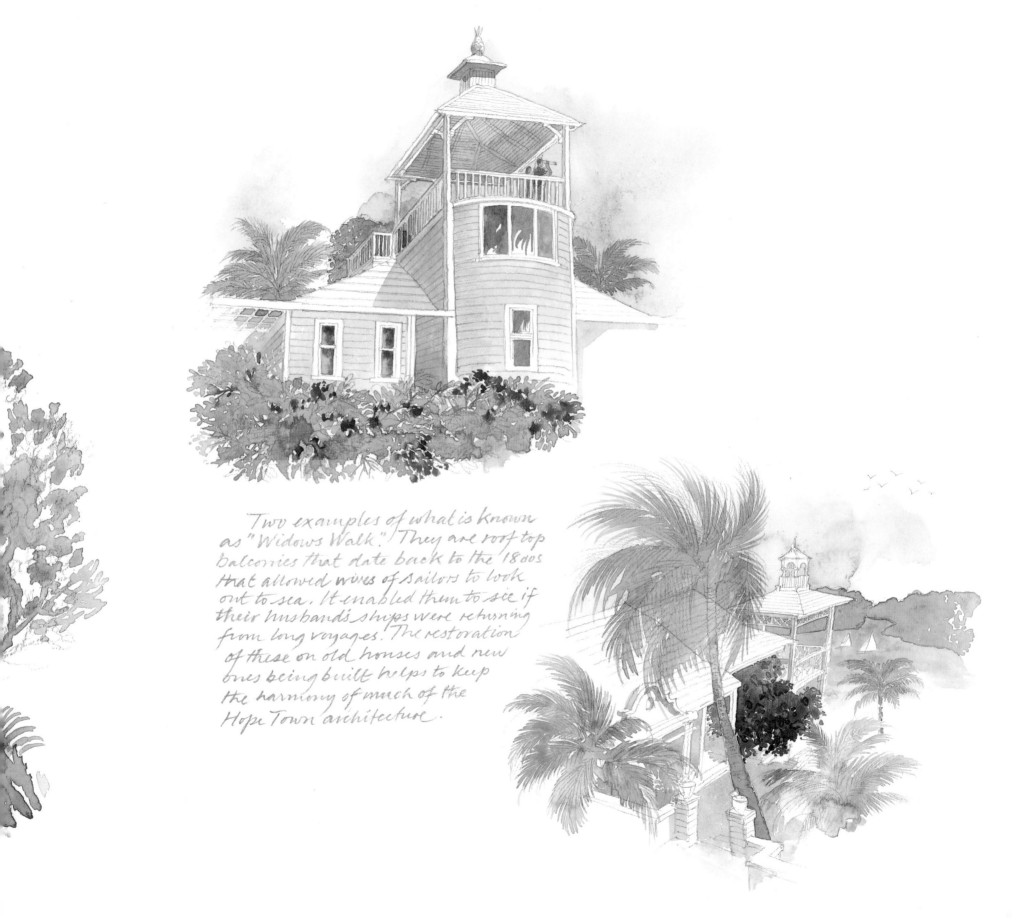

Two examples of what is known as "Widows Walk." They are roof top balconies that date back to the 1800s that allowed wives of sailors to look out to sea. It enabled them to see if their husband's ships were returning from long voyages. The restoration of these on old houses and new ones being built helps to keep the harmony of much of the Hope Town architecture.

During the 1860s the British Imperial Lighthouse Service built this lighthouse to stop ships going aground on the rock of Elbow Reef, where previously many ships had been wrecked.

The Hope Town Inn and Marina, a new boutique resort designed by resident architect Michael Myers. The overall style complements the loyalist theme of the original settlement. The copula even has a light, like the lighthouse, to help the boats dock in the marina at night.

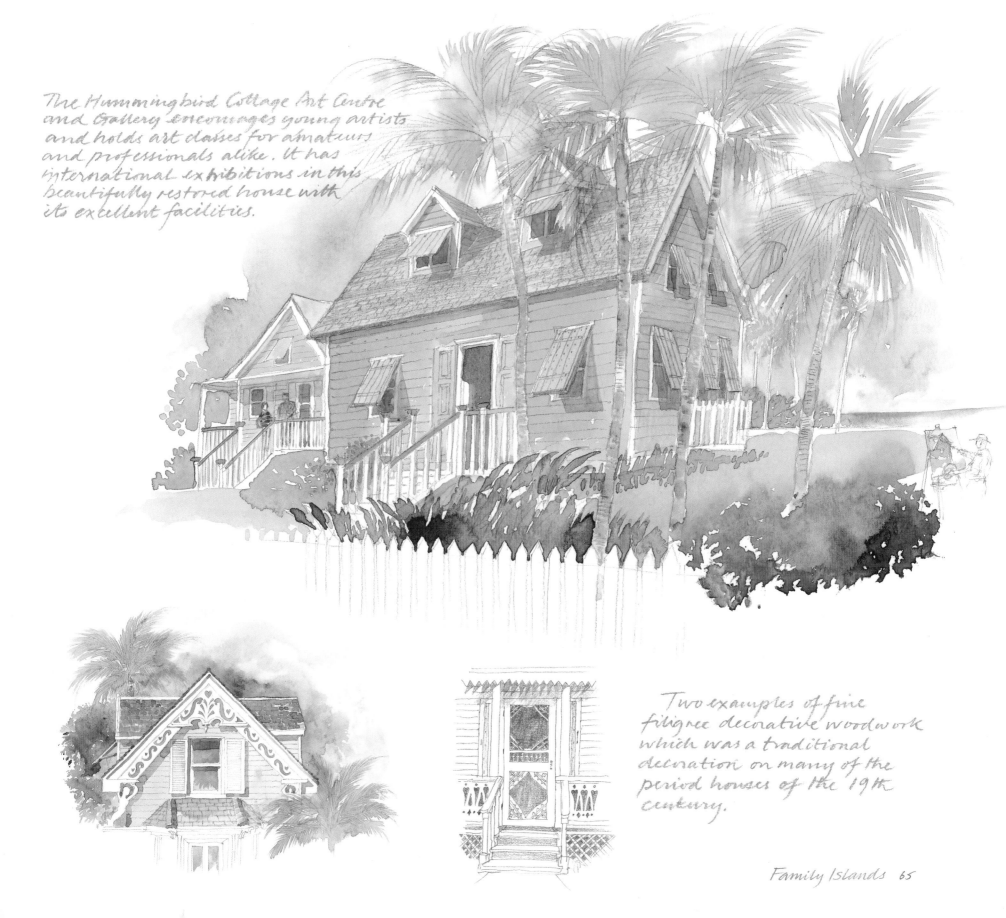

The Hummingbird Cottage Art Centre
and Gallery encourages young artists
and holds art classes for amateurs
and professionals alike. It has
international exhibitions in this
beautifully restored house with
its excellent facilities.

Two examples of fine
filigree decorative woodwork
which was a traditional
decoration on many of the
period houses of the 19th
century.

Docking at Schooner Bay at sunset after a hard day fishing. Time for a sundowner.

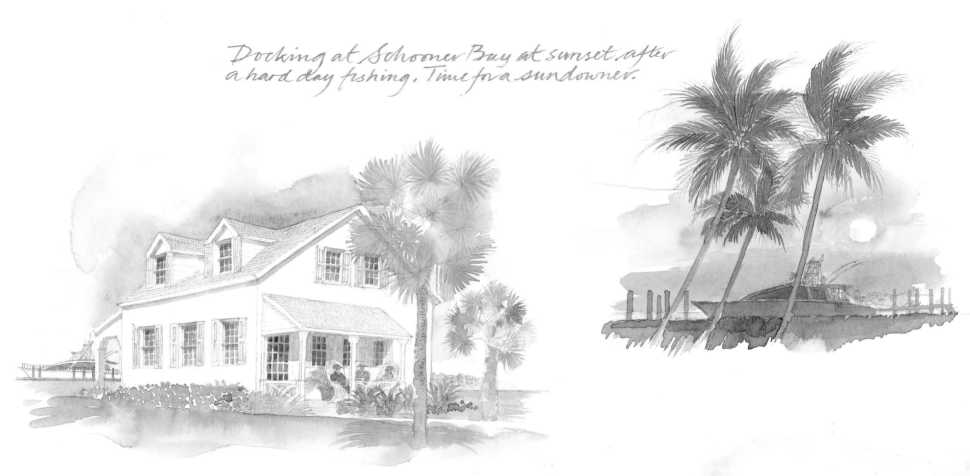

The houses by the water have a private dock where most boats of various sizes can moor.

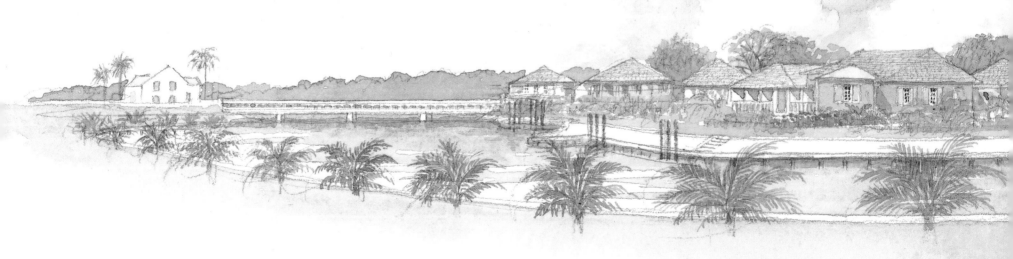

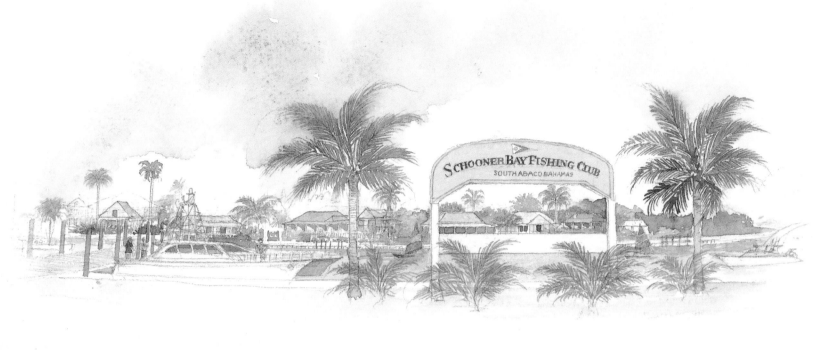

Schooner Bay is a new harbour village built in the timeless tradition of Bahamian seaside settlements. Life centres around the harbour and its island, and the neighbourhoods that extend inland. As the harbour on the busy south coast of Atlantic Abaco, it is an important stop for passing vessels.

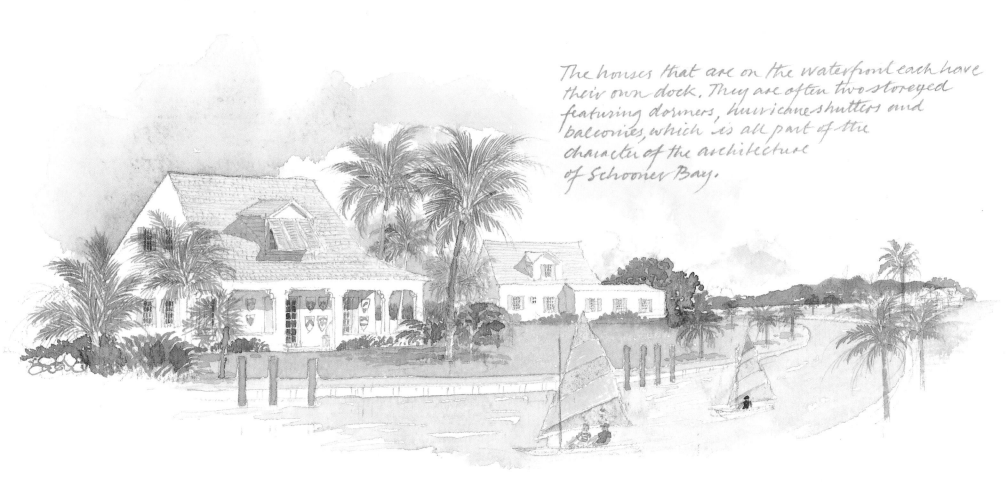

The houses that are on the waterfront each have their own dock. They are often two-storeyed featuring dormers, hurricane shutters and balconies, which is all part of the character of the architecture of Schooner Bay.

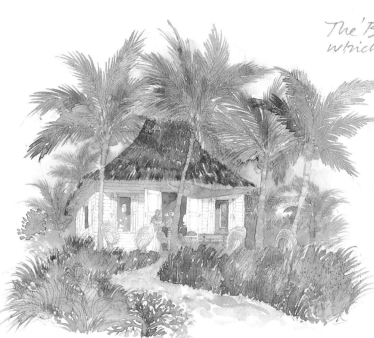

The 'Beach Cabana' is a thatched building which combines the vernacular of a native bungalow and the classic proportions of a great house. The windows and doors align to create cross ventilation and the thatch roof is a shade from the sun. The thatch is robust and will withstand hurricane winds.

Sitting as a centrepiece at the head of Schooner Bay is Black Fly Lodge, a classic Bahamian vernacular house. The design combines practicality of the local climate with timeless principles of proportion. The second-floor rooms are accessed by by outside stairs leading to the verandah and the cupola room is reminiscent of Captain's Walk used for seeking news of returning ships.

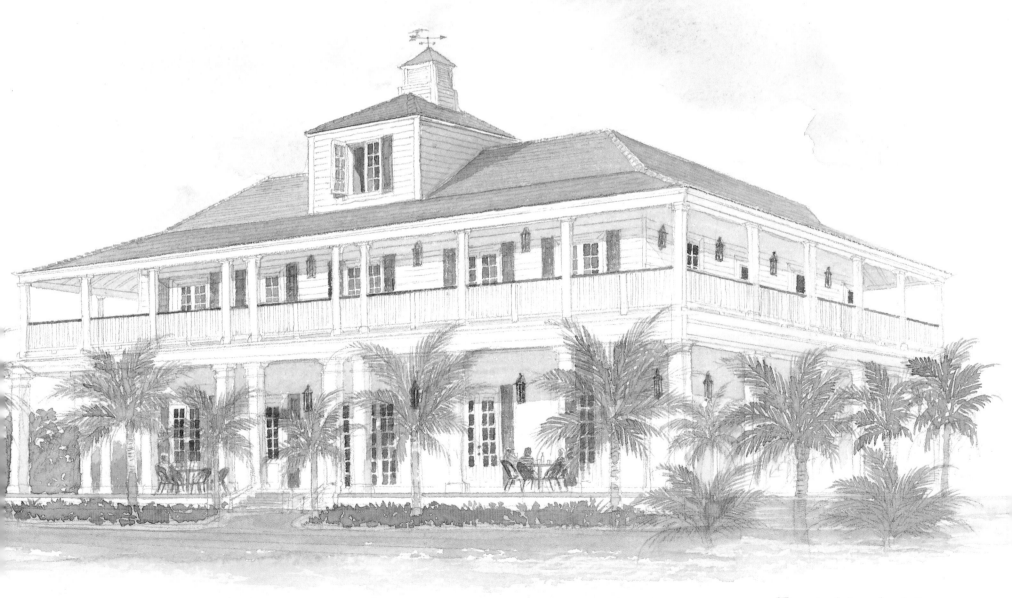

Cat Island

The island has the highest point in the Bahamas of 206 feet. Mount Alvernia has a magnificent view over the ocean. On this mountain a Roman Catholic priest named Monsigneur Jerome Hawes chose to build The Hermitage. It had a bell tower, kitchen, study, cloister and a small bedroom. Monsigneur Hawes was a very clever architect and stonemason and built a number of churches on different islands. He lived at the Hermitage the last ten years of his life. He died at 79 years of age on 26 June 1956 and requested to be buried in a cave near his beloved Hermitage.

The kitchen of Deveaux House. All the great plantation houses that now are in ruins had separate kitchens and ablutions away from the grand house.

Deveaux House. Now an elegant ruin which should be restored. The house is very large and looks as if it could be one of the South Carolina mansions with views towards Port Howe and the sea. It was built by Colonel Andrew Deveux, who in 1783 was responsible for the freedom of Nassau from the Spanish, for which he received 1000 acres upon which he built the house and plantation.

San Salvador

On the discovery of the New World by Christopher Columbus, landing on San Salvador in 1492, he wrote in his journals, "The beauty of these islands surpasses that of any other and as much as the day surpasses the night in splendour." Even today the islands live up to that long-ago sentiment.

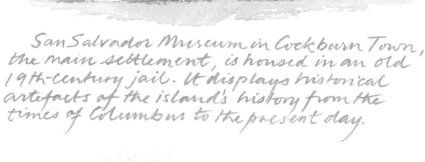

San Salvador Museum in Cockburn Town, the main settlement, is housed in an old 19th-century jail. It displays historical artefacts of the island's history from the times of Columbus to the present day.

THIS PLAQUE WAS PRESENTED BY THE GOVERNMENT OF SPAIN ON THE OCCASION OF THE VISIT OF THE REPLICAS OF CHRISTOPHER COLUMBUS CARAVELS ON 10TH FEBRUARY 1992 IN COMMEMORATION OF THE FIRST LANDFALL AT SAN SALVADOR IN 1492

1492 – 1992

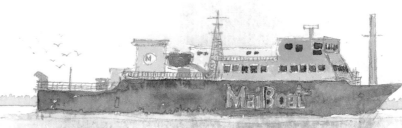

The mailboat arrives. Still an exciting moment for the local inhabitants.

Long Island

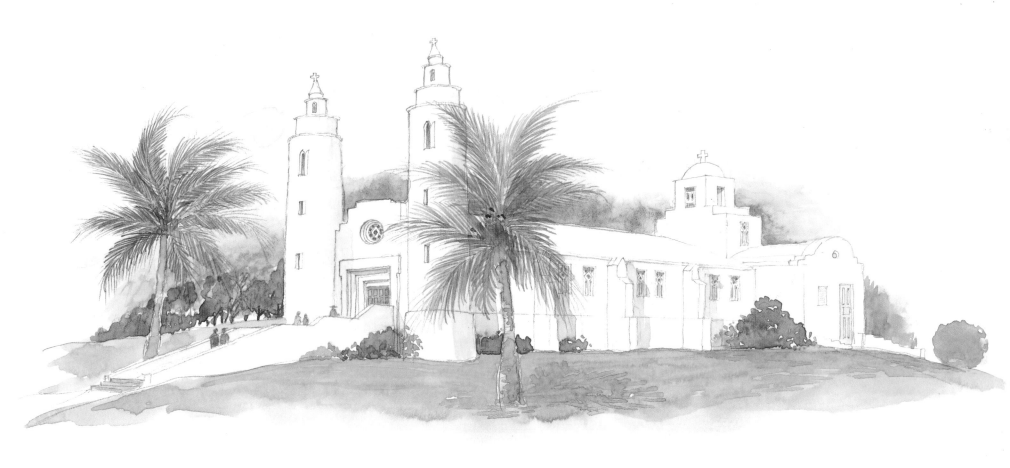

This book on the heritage of Bahamas architecture
finishes with a wonderful example of a conserved building.
It is another church built by Monsigneur Jerome Hawes,
in 1946. A Catholic church, small but powerful, its white form
is an impressive sight standing high above Clarence
Town, the capital of Long Island, against a blue Bahama sky.

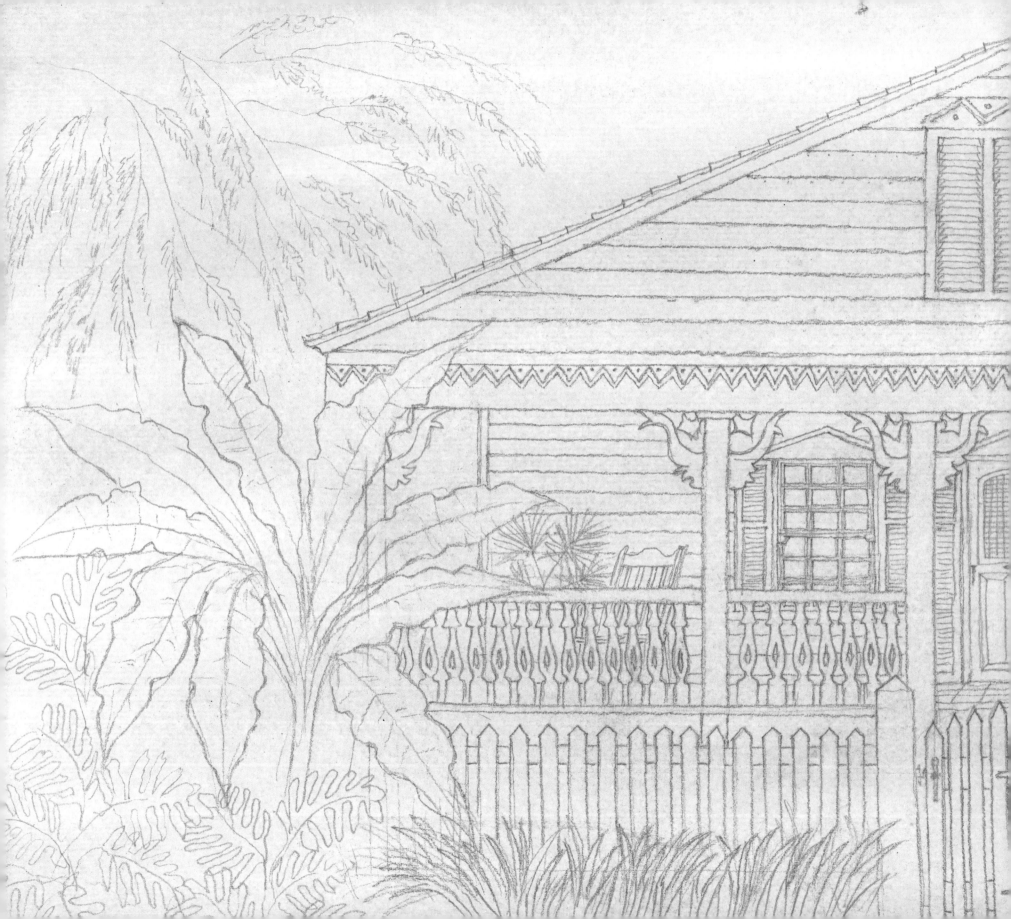